IMAGES
of America

CATASAUQUA AND NORTH CATASAUQUA

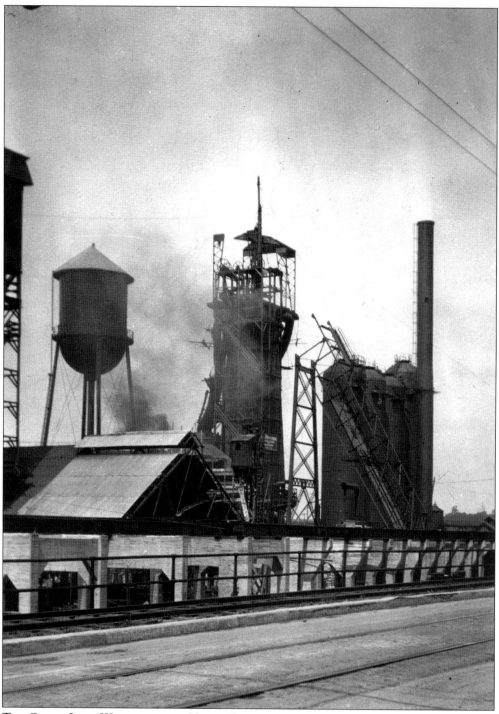

The Crane Iron Works, with a Newly Built Furnace No. 2, June 1920. Front Street, between Church and Bridge, is in the foreground. Despite a major renovation of the plant in 1919–1920, it was completely shut down in 1921.

IMAGES
of America

CATASAUQUA AND NORTH CATASAUQUA

Martha Capwell Fox

ARCADIA

First printed in 2002.

Published by Arcadia Publishing,
an imprint of Tempus Publishing, Inc.
2A Cumberland Street
Charleston, SC 29401

Printed in Great Britain.

Library of Congress Catalog Card Number: 2002108555

For all general information contact Arcadia Publishing at:
Telephone 843-853-2070
Fax 843-853-0044
E-Mail sales@arcadiapublishing.com

For customer service and orders:
Toll-Free 1-888-313-2665

Visit us on the internet at http://www.arcadiapublishing.com

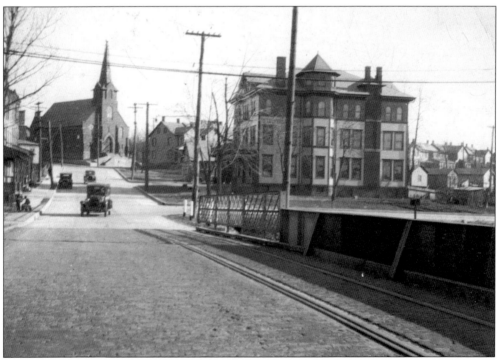

THE ARLINGTON HOTEL AND ST. ANDREW'S CHURCH. This photograph was taken from the Hokendauqua Bridge in the 1930s.

CONTENTS

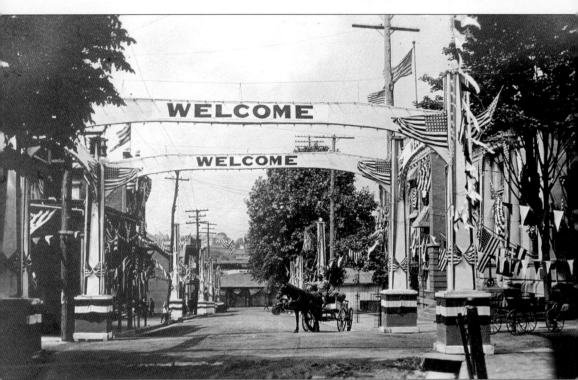

THE COURT OF HONOR, BRIDGE AND SECOND STREETS, OLD HOME WEEK. From June 28 to July 4, 1914, Catasauqua observed the 75th anniversary of David Thomas's first successful iron blast by inviting the world to come and celebrate the Iron Borough's fame and prosperity. A week of parades, prayers, songs, amusements, athletic contests, and public and private gatherings culminated with a huge Independence Day parade. However, a dark future loomed. While Catasauqua stories filled the front pages of Allentown's newspapers, relegated to the back was the news of the assassination of Austria's grand duke, shot that week in Sarajevo. Within weeks, Europe was engulfed in World War I. Three years later, hundreds of Catasauqua boys went to war and Catasauqua raised millions in war-bond funds, earning a new nickname, the "million-dollar town."

INTRODUCTION

When the 20th century opened, Catasauqua was one of the most prosperous towns in the United States. The anthracite iron industry, born here in 1840, had triggered a wave of industrial innovation that made Catasauqua famous and many Catasauquans rich. Along the banks of the Lehigh River and the Lehigh Coal and Navigation Canal stood the Crane Iron Works, which spawned dozens of similar mills up and down the river, and far beyond the confines of the Lehigh Valley. Around the Crane clustered dozens of other businesses, including foundries, rolling mills, and fabricators of boilerplates, railroad-car wheels, and tunnel tubes, which came into being because David Thomas, or one of his Welsh friends and business partners, saw a way to make something new, useful, and profitable from iron. Newer industries, like silk weaving, rubber fittings, gas and electricity generating, were growing in importance as Catasauqua moved into the 1900s. The Iron Borough was a microcosm of American industry, a textbook example of how success breeds success.

David Thomas and his son Samuel walked into Biery's Port on the Lehigh Coal and Navigation towpath on July 9, 1839. Less than a year later, on July 4, 1840, Thomas put into blast the first commercially successful anthracite iron furnace. When he arrived here, Thomas found a tiny handful of houses, a few farms, and a gristmill. When he died here, beloved and wealthy, almost 43 years later, Thomas left two industry-leading iron mills, several companies that made products from his iron, and a bustling, prosperous town. Even more, he left a transformed United States, which he had played a large part in making the industrial leader of the world.

Thomas came to Catasauqua armed with the knowledge of how to use anthracite coal, which was coming down the canal from the mines of Carbon County, to make large quantities of excellent-quality iron. Before Thomas, iron in this country was produced only in small lots, using charcoal to fuel the furnaces. This was slow and inefficient, and charcoal-making was using up America's timber faster than it could be replenished. Josiah White and Erskine Hazzard, who had built the Lehigh Coal and Navigation Canal to bring the anthracite coal from the mountains to Philadelphia, brought Thomas from Wales to make iron with their coal. They sent him to this rural part of the Lehigh Valley because it was one of the few places on the canal where there was enough waterpower to drive a turbine. In one remarkable year of hard work, vision, and persistence, Thomas almost single-handedly created an iron furnace, a town, and the industrial age in America.

What happened next was repeated in towns and rural areas all over the Lehigh Valley,

Pennsylvania, and much of the Northeast. Farmland, rural hamlets, and small towns suddenly mushroomed into smoky, noisy industrial centers, which quickly attracted new people—American and immigrant alike. Suddenly, everything was different and new—new houses, new businesses, new churches, new languages, and new ways of life.

Catasauqua quickly spread out along the canal and river, and up the hills that rose gently from their banks. Where only several dozen people had lived in 1840, there were over 3,000 in 1860. By 1900, Catasauqua had more than 5,000 inhabitants, and a higher percentage of them were millionaires—self-made millionaires—than anywhere else in the nation.

They were proud, self-confident, hardworking, and energetic men, devoted to building their businesses and their community. When these men or their wives saw something that needed doing, or that they thought would improve the lives of Catasauquans, they did it. Though nearly every one of those businesses are now gone, and most of those families died out or moved on, 100 years later we still live with the signs and symbols of their achievements. Schools and churches, playgrounds and fire companies, mansions and row houses, and a strong sense of identity as Catasauquans are with us still.

This is by no means a comprehensive pictorial history of Catasauqua and North Catasauqua. Readers will notice the absence of some well-known landmarks, such as the tunnel; a few industries, most notably brewing; and some famous faces, such as World War II ace Tommy Lynch. In some cases, this is because pictures that met the quality requirements of the publisher did not turn up. Also, so many pictures that had not been published before were offered by residents of both boroughs that the author decided to give space to these, rather than other, more familiar photographs. In this sense, this book is a community photograph album. The author has tried to include as many historical facts and analyses as possible without making the text unwieldy. Many more pictures came to light than could have been included in this volume. The author hopes that this book will send the people of Catasauqua and North Catasauqua searching through their albums, attics, and drawers to bring to light more photographs that will help show and tell the story of what it has been like to live here.

One
THE IRON AGE

Iron made Catasauqua. For 80 years, virtually all of Catasauqua's industrial, financial, and business life was driven by making iron and then fabricating it into the materials that built America. The Iron Borough's iron industry survived the economic storms of the late 19th century, which buffeted the nation's economy as a whole and the iron business in particular. Long after the national center of iron and steel making had moved west to Pittsburgh, and the neighboring Bethlehem Iron Works had switched to steel, the Crane Iron Works, later the Empire Steel and Iron Company, made both iron—130,000 tons of it in 1904—and money. As long as the iron company made money, so did every one else in Catasauqua.

But the Empire Steel and Iron Company's apparent prosperity was something of an illusion. Company president Leonard Peckitt was a savvy and energetic businessman who diversified his company until it had assets that included other blast furnaces, ore mines in New Jersey, two small railroads, and a coal and coke company in West Virginia, as well as a fair amount of real estate in Catasauqua and elsewhere. The profits from some of these other interests helped cloud the fact that the company was losing money in iron making as early as 1908. The demands of the war effort temporarily bolstered the Crane's resources. However, with armament production nearly ceased after the armistice, and the recession of 1919, the cracks in the iron business became glaringly apparent. An optimistic, but ultimately ill-chosen investment in plant renovation, costing $1 million, was fruitless, and the last iron furnaces went out in 1921. Catasauqua's golden age of iron was over.

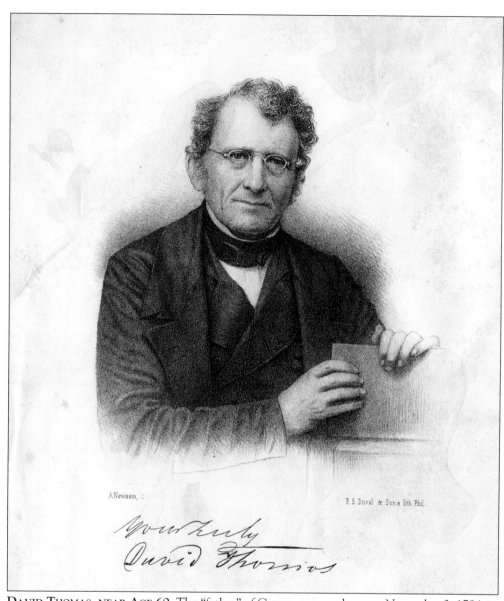

Yours truly
David Thomas

DAVID THOMAS, NEAR AGE 60. The "father" of Catasauqua was born on November 3, 1794, in Wales. One of the most experienced ironmasters in Britain, Thomas was persuaded by the owners of the Lehigh Coal and Navigation Company to come to Pennsylvania in 1839. They hired him to build a blast furnace capable of using the anthracite coal that was carried from Mauch Chunk to Easton on their canal. Thomas put the first commercially successful anthracite iron furnace into blast at Catasauqua on July 4, 1840, thus launching the industrial age in the United States. Thomas, a devout Presbyterian, founded the first church in Catasauqua, laid out the streets, instituted a public water system (an ardent teetotaler, Thomas believed that a good supply of drinking water would keep men from drinking alcohol), organized the first fire company, built the Crane company houses that line Wood and Church Streets, and served as the first burgess of the borough. Thomas was the first president of the American Society of Metallurgy, and he was a founder of the American Association of Industrial Engineers. He died in Catasauqua on June 20, 1882, and is buried in Fairview Cemetery.

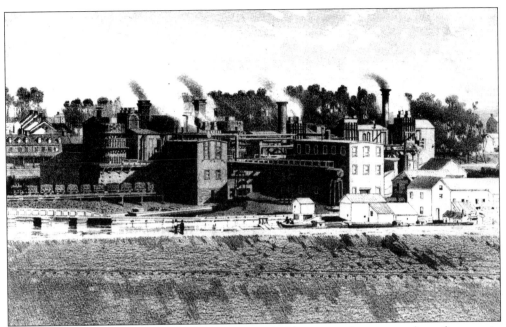

THE LEHIGH CRANE IRON WORKS, C. 1860. At this time, there were three furnaces in operation with a combined average weekly output of some 400 tons. Lock 36, with a canal boat locking through, is in the center of the image, and part of a boatyard, used for repairs and winter storage, is visible on the left. The company was chartered as the Lehigh Crane Iron Company in 1839 and renamed the Crane Iron Company in 1872.

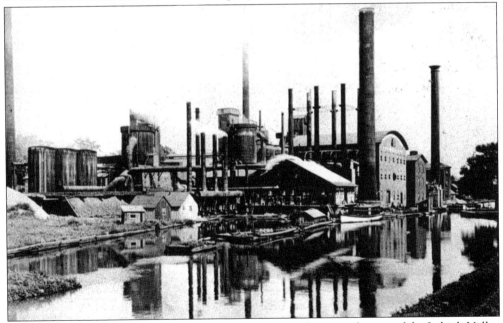

THE CRANE IRON WORKS, C. 1890. Though the iron industry in the rest of the Lehigh Valley had seriously declined in the previous decade, good management, good luck, and income from diverse outside sources, such as land, had helped the Crane survive and even flourish. In 1900, the Empire Steel and Iron Company's Crane works produced about 100,000 tons of pig iron.

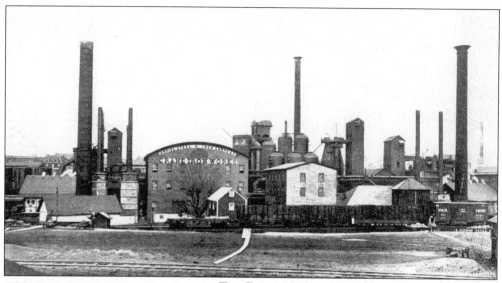

THE EMPIRE STEEL AND IRON COMPANY

OWNING AND OPERATING

THE CRANE IRON WORKS, CATASAUQUA, PENNA.
THE ALLENTOWN IRON WORKS, ALLENTOWN, PENNA.
THE TOPTON FURNACE, TOPTON, PENNA.
THE MACUNGIE FURNACE, MACUNGIE, PENNA.
THE READING FURNACES, READING, PENNA.
THE OXFORD FURNACE, OXFORD, N. J.
THE GREENSBORO FURNACE, GREENSBORO, N. C.
OXFORD MINES, MT. HOPE MINES, ETC.

OFFICERS:
LEONARD PECKITT, President.
J. M. FITZGERALD, Secretary. J. S. STILLMAN, Treasurer.

GENERAL OFFICE:
Catasauqua, Penna.

NEW YORK OFFICE:
Empire Building, 71 Broadway.

———

ROGERS, BROWN & CO.
SOLE SELLING AGENTS
IN ALL MARKETS.

THE EMPIRE STEEL AND IRON COMPANY, C. 1904.
Leonard Peckitt took over as president of the Crane Iron Works in 1898 and proceeded to create a small iron empire. The following year, he incorporated the Empire Steel and Iron Company, and quickly acquired iron mills in Allentown, Macungie, Topton, Reading, and Oxford, New Jersey, as well as iron ore mines in Mount Hope, New Jersey. However, the company's crown jewel was the Crane (above), where four blast furnaces turned out 450 tons of iron daily in 1902.

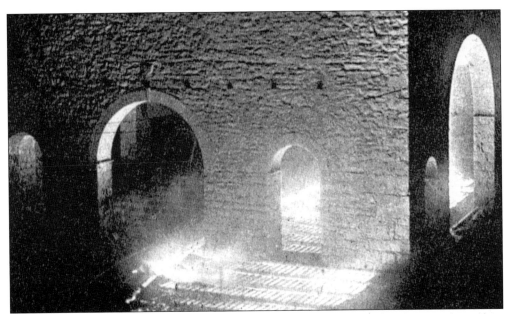

A CASTING FLOOR AT THE CRANE. After iron ore was melted in the blast furnace, the molten iron was allowed to flow into channels of wet sand. There, it hardened into pigs, bars of iron three feet long, weighing about 60 pounds. Workers wearing wooden clogs then picked up the pigs by hand and with tongs.

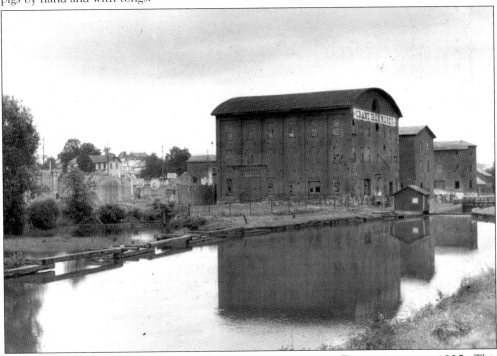

THE BLOWING ENGINE BUILDING, SHORTLY BEFORE BEING DEMOLISHED, C. 1935. This building with the curved roof is prominent in photos of the Crane after c. 1890. It housed the blowing engines that forced hot air into the blast furnaces. This photograph was taken after much of the plant was torn down in the early 1930s.

THE HEADQUARTERS OF THE EMPIRE STEEL AND IRON COMPANY. When Leonard Peckitt consolidated the Crane Iron Company with several other furnaces in Pennsylvania, New Jersey, and elsewhere under the Empire banner in 1899, he located the headquarters in this building, constructed in 1900 at 124 Bridge Street. After ownership of the Empire passed to Replogle Steel in 1922, Col. James W. Fuller bought the building and it became the headquarters of the Fuller Company, incorporated in 1926.

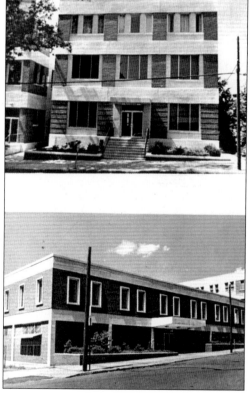

THE SAME BUILDING, KNOWN AS FULLER COMPANY BUILDING NO. 1, THE LATE 1960s. Buildings No. 1 and No. 2 (the former post office at 122 Bridge Street) were refaced in 1966 to resemble the Fuller building No. 3, built by GATX in 1966, at 118 Bridge (now borough hall). Fuller sold Building No. 1 in 1984, and it is now My Home personal care facility.

Two
MADE IN CATASAUQUA

Part of David Thomas's genius was ensuring that he had ready customers for the iron he was producing at the Lehigh Crane Iron Works. John Fritz's Union Foundry, the first in the Lehigh Valley and one of the first in the United States, opened just north of the iron works at Front and Pine in 1851. There, Fritz produced the first American-made cast-iron construction columns. Thomas bought that company in 1854, running it with his sons until selling it to Oliver Williams in 1869. Thomas also leaped at the chance to become one of the first makers of armor plate for naval vessels during the Civil War, setting up a rolling mill later called the Catasauqua Manufacturing Company. The mill did not get going before Lee's surrender ended the need for armor, so Thomas switched to making tank, boilerplate, and sheet iron. The Davies and Thomas foundry on Race Street shaped Crane iron into large pipes and tunnel tubes, which went into the expanding underground infrastructure of America's cities. And the Bryden Horse Shoe Company turned Crane iron into horseshoes.

Catasauqua and North Catasauqua became a microcosm of 19th-century industrial development. Alongside the heavy industries sprang up businesses to support and supply them. Firebricks and rubber fittings were made in Catasauqua. As the town boomed for most of the latter half of the 19th century, modern improvements like electricity (installed in Catasauqua by Thomas Edison) and a reliable water system lured other business, like silk weaving. All of this was driven by a group of men, mostly Welsh, close-knit by business and marriage, who seized every opportunity to make products—and fortunes—in Catasauqua.

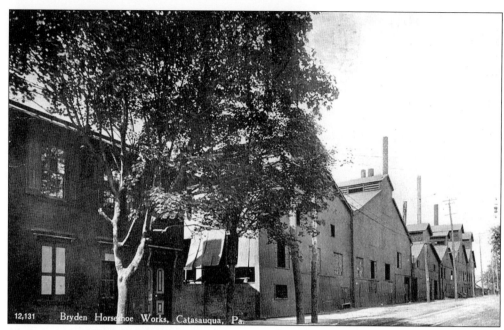

12,131 Bryden Horseshoe Works, Catasauqua, Pa.

THE BOSS
STEEL RACING PLATE
MANUFACTURED ONLY BY THE
BRYDEN HORSE SHOE CO
CATASAUQUA, PA.
UNDER THE
COVINGTON-KENT PATENTS
SEND FOR CATALOGUE.

THE BRYDEN HORSESHOE WORKS ON UPPER FRONT STREET. The Bryden Horse Shoe Company was opened in 1882 by Oliver Williams. Two years after, he came to Catasauqua to run the Catasauqua Manufacturing Company. Williams was looking for a way to use the iron products from his rolling plant and bought the patent rights for the Bryden process, which made horseshoes entirely by hammer. The first Bryden plant was located at Strawberry and Railroad Streets; the above building was built in 1888. The Bryden was one of the largest horseshoe plants in the world, producing between 40 and 50 tons daily, and supplied the British cavalry with horseshoes during the Boer War in southern Africa. The Bryden Neverslip was one of the most-used types of winter shoes for horses that pulled city streetcars.

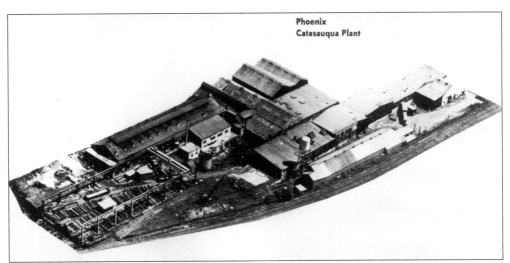

Phoenix
Catasauqua Plant

THE PHOENIX MANUFACTURING COMPANY, C. 1940. As the horseshoe market disappeared, the Bryden (above) was acquired in 1928 by the Phoenix Manufacturing Company of Poughkeepsie, New York. The Phoenix was determined to stay in business by branching into other forging operations, and modernized the Catasauqua plant in 1939. The Phoenix carried on making commercial forgings and flanges (below) and, by 1953, had 21 hammers, ranging in size from 1,200 to 4,000 pounds. The Phoenix Forging Company, a subsidiary of Barco Industries of Reading, still operates on the site.

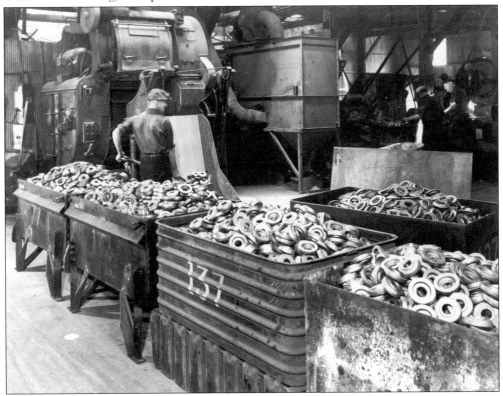

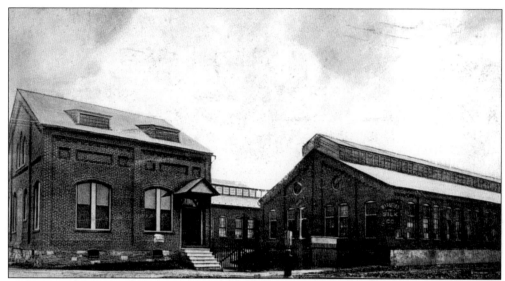

THE WAHNETAH SILK MILL, C. 1905. The Wahnetah opened in 1890 as a small plush mill. William Thomas converted to broad dress silk looms in 1902, and by 1918, the large mill on the canal road had 755 looms and over 550 employees. After the Wahnetah went out of business in 1935, the mill was divided between Cands Fabrics and Catasauqua Weaving. Silk production continued until 1971. In 1982, the building, then occupied by Jackson-Allen furniture company, was destroyed in a fire. The site was turned over to the Lehigh County Historical Society, which created the park in front of Taylor House.

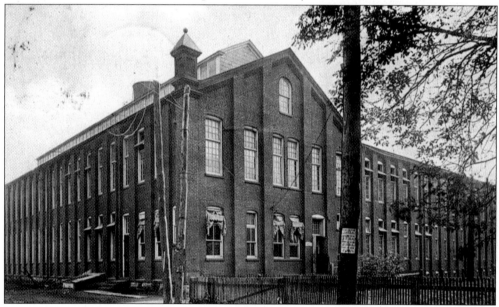

THE DERY SILK MILL, C. 1900. D. George Dery, already a successful silk weaver, came to Catasauqua in 1897. He built this mill after filling in the former millpond, which had driven the gristmill at Race and Lehigh Streets. This was the first in a small empire of mills that made Dery the largest individual silk maker in the world. Dery lost everything in the silk market crash of 1923. The building housed several more textile and ribbon makers until being converted to apartments in 1984. It is now on the National Register of Historic Places.

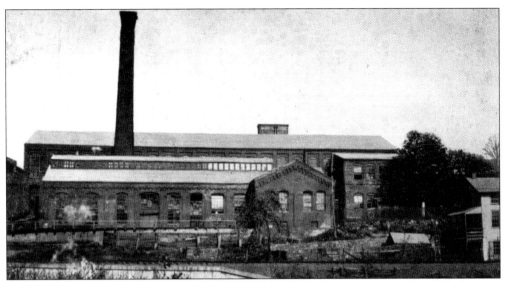

The Unicorn Silk Mill after 1894. The Unicorn may have been the first silk mill in the boroughs. The date of its opening is unknown, but the building was destroyed in 1890 by a fire that killed five men and injured dozens. Rebuilt and still standing at 1151 Front Street, this building housed various companies that made plushes, broad silks, and ribbon. The companies included the Degener Brothers, owned by Lund and Roeth Degener, and Starck Brothers, which operated as General Ribbon.

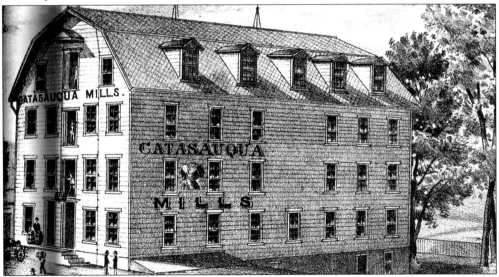

The Catasauqua Gristmill, from the 1876 Atlas of Lehigh County. A gristmill was built on the banks of Catasauqua Creek near the Lehigh in 1752, but the names of the owners before the Biery family bought it in the early 1800s are unknown. When this print was made, William Younger, who lost the business to bankruptcy in 1891, was the owner. Frank Mauser and Allen Cressman took over in 1898, installed new equipment, switched their power source from the millpond east of the mill on Race Street to the Lehigh canal, and suffered a devastating fire that same year. Rebuilding, they doubled their capacity and quickly gained a significant share of the local flour market. Though the exterior is altered, this building still stands at the corner of Race Street and the canal road.

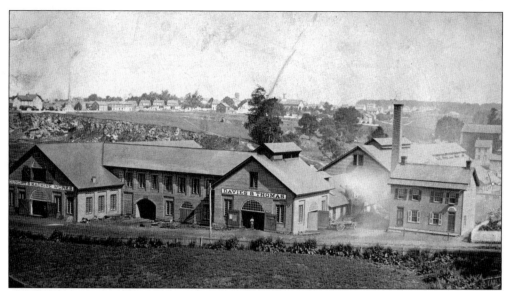

THE DAVIES AND THOMAS FOUNDRY, C. 1914. Daniel Davies opened a foundry (above) on Race Street on the east bank of the Catasauqua Creek in 1865. By 1900, it was a major manufacturer of gas pipes and cast-iron tunnel components and had supplied over 80 percent of the tube structures for the tunnels of New York City. One such tunnel part (below) is pictured in 1904. The firm supplied tube castings for the Holland, Lincoln, Mid-Town, and Battery/Brooklyn Tunnels (the last project before the firm closed in 1948) in New York City, as well as for Pennsylvania Railroad tunnels under the Harlem River and at McAdoo.

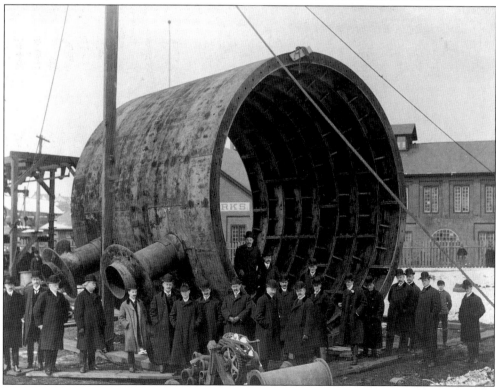

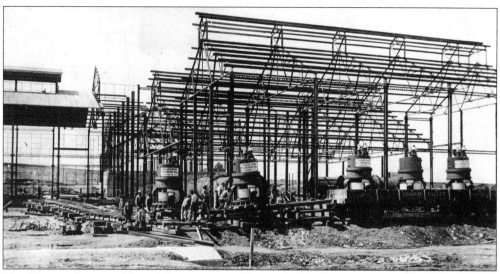

THE FULLER LEHIGH MILL, MAY 13, 1907 (ABOVE). The Fuller family had owned a major interest in the Lehigh Car, Wheel and Axle Works since 1866, but its fortunes fluctuated with those of the railroads. By the early 20th century, James W. Fuller Jr. saw that the burgeoning cement industry offered far more opportunity, and he began to develop machinery for use in making cement. An early success was the Fuller Mill (below), a pulverizer that ground rock and clinker coal into an ultra fine powder. Fuller's son, Col. James W. Fuller III, sold the rights to the Fuller Mill to Allentown Portland Cement Company. However, the company defaulted on payments, allowing Fuller to acquire a controlling interest in that company and retain ownership of his father's innovation. In 1918, he changed the now archaic Lehigh Car, Wheel and Axle name to Fuller-Lehigh.

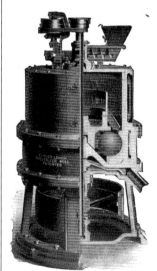

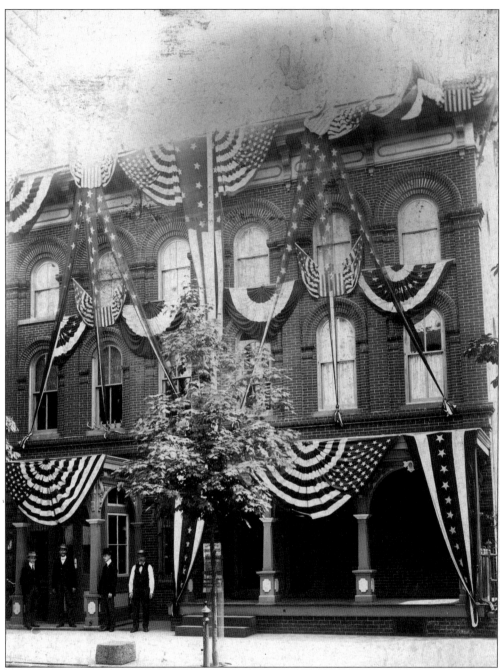

THE IMPERIAL HOTEL, DECORATED FOR OLD HOME WEEK. The original part of this building was a two-and-one-half-story store, which was converted into the first permanent home of the National Bank of Catasauqua in 1858. After the bank moved to its present location at Second and Bridge Streets, the building became the Imperial Hotel, with an impressive mahogany bar in the first-floor saloon, offices on the second floor (the name of attorney and insurance man, Austin A. Glick, is visible on the left windows), and accommodations for 75 guests. The building still stands at 137–139 Front Street.

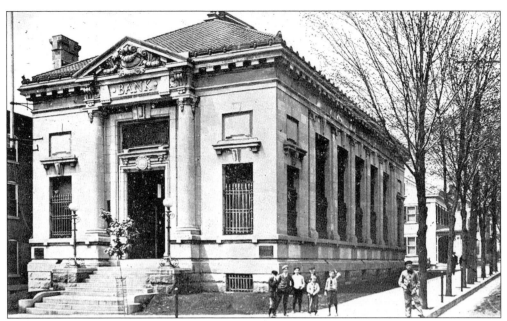

THE NATIONAL BANK OF CATASAUQUA, C. 1910. In 1858, David Thomas offered the land the bank now stands on free to the bank's trustees. They turned him down. They had to pay for the property 45 years later, and erected this building at a cost of over $75,000. This in no way denigrates the business acumen of the bank's directors, who weathered every major financial storm of the 19th and early 20th centuries. In 1914, the bank had capital of over $1.5 million on hand. The bank became part of First National Bank of Allentown in 1955, which in turn was consolidated into Meridian Bancorp, then Core States, then First Union, and most recently, Wachovia.

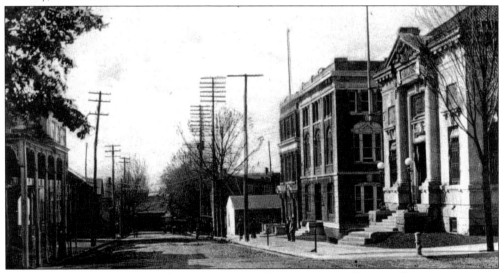

THE NORTH SIDE OF BRIDGE STREET, BETWEEN RAILROAD AND SECOND STREETS, C. 1910. At the height of its prosperity, the commercial and financial hub of Catasauqua was in this half block. The post office is visible down the street, with the Empire Steel and Iron headquarters in the middle and the bank on the right. The Eagle Hotel and the engine shed of the Crane Railroad are visible at the intersection of Front and Bridge Streets.

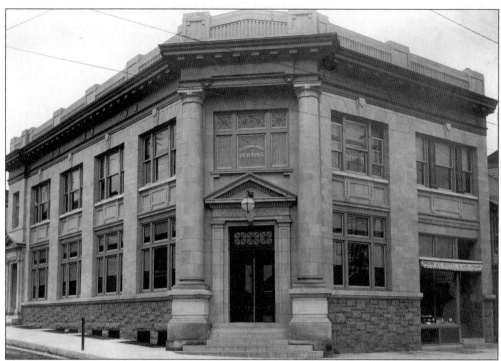

THE LEHIGH NATIONAL BANK, C. 1910. Catasauqua's second bank was chartered on April 26, 1906, and did business at 423 Front Street, a building owned by William Glace, bank president. In 1905, the bank bought the property at the corner of Front and Bridge Streets for $18,000, and, in 1910, opened the building above, which still stands there. From 1910 to 1951, Beitel's Jewelry store occupied a space in the bank on the Front Street side. The bank closed in the mid-1950s, and the building is now the Lehigh Valley Acupuncture Center. Bank president James Beitel and several members of his staff are pictured in an undated photograph below.

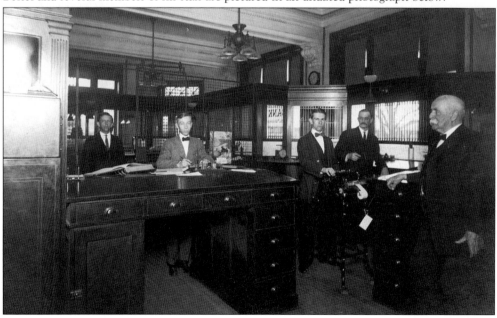

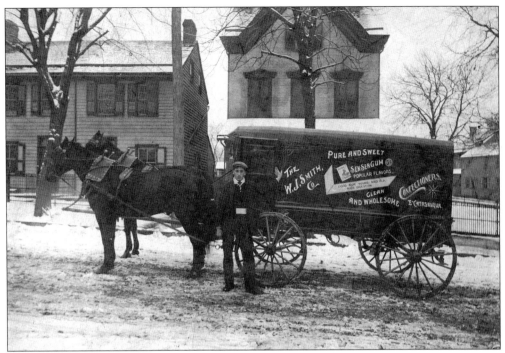

THE SMITH CANDY COMPANY'S DELIVERY WAGON, 1904 (ABOVE). The Smith Candy Company began in the basement of a general store on Race Street in 1895 and, three years later, built a brick building at what is now the northwest corner of Race and Twelfth Streets. In 1910, the company bought one of the first Mack trucks used anywhere in the United States to deliver its sweets and, in 1914, moved to the building on Race Street (below), which it occupied until the business ended in the 1970s.

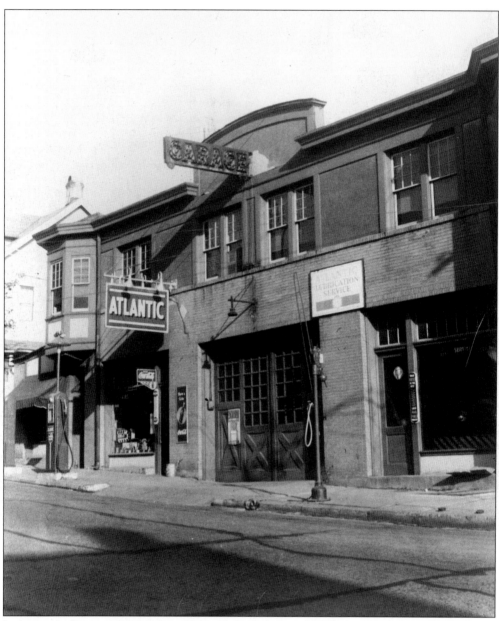

LYNCH AND DUGAN GARAGE, C. 1940. Philip Lynch and Nicholas Dugan were the first men in the automobile business in Catasauqua. In 1911, they opened a small car-repair shop at 115 Pine Street, the location pictured here. Their first shop included a converted merry-go-round that had stood at the back of their building. After becoming Ford dealers in 1914, they purchased and razed the blacksmith shop across Pine Street and built a large garage and showroom in a building that now houses Catty Beverage. Lynch and Dugan also sold Hudson, Essex, Flint, Durant, and Star automobiles until they reverted purely to gasoline retailing and car repair in 1932. This building still stands, with retail space on the first floor and apartments on the second.

BLOCKER'S SERVICE STATION, C. 1939. Luke Blocker (right) and his son Earl operated a Tide Water service station at Bridge and Front Streets from 1930 to 1939. That year, they bought the lot containing the old Crane stables on Front Street, north of Wood, and built this building, which was later expanded and has operated as a hardware store and gas station since. In 2002, the business was purchased by Vince Smith, who incorporated his auto-body business with the hardware store. The woman on the left is Mary Blocker, wife of Earl.

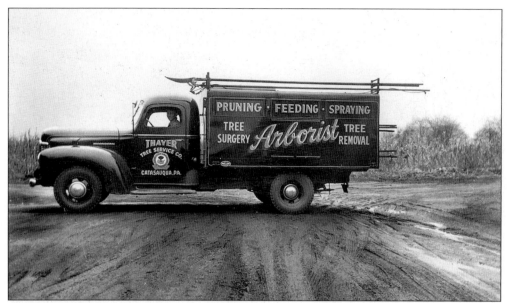

THAYER TREE SERVICE TRUCK, C. 1940. Thayer trucks were once a familiar sight on the streets of Catasauqua and North Catasauqua, as it was the premier tree service in the two boroughs.

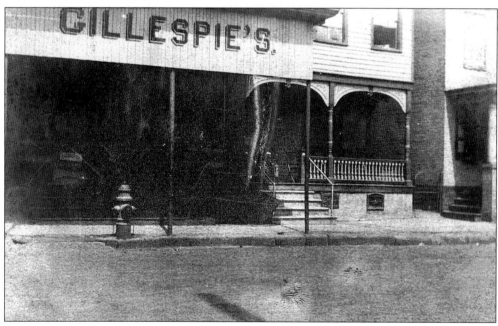

GILLESPIE'S STORE, MULBERRY AND SECOND STREETS, C. 1910. Small stores like Gillespie's were found all over Catasauqua, offering staples like bread, coffee, sugar, and soap. This general store was established by John Brown in 1849. David Gillespie Sr. took over in 1865 and was succeeded by his son David in 1904. Like many store owners, the Gillespies themselves lived at their business, in the house visible next door.

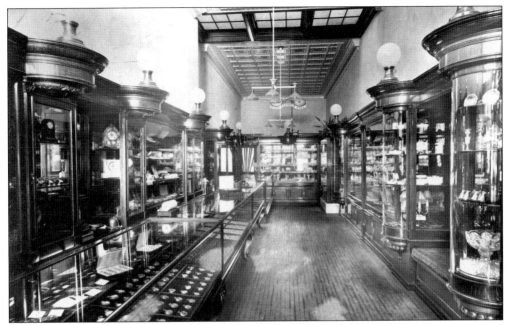

THE INTERIOR OF BEITEL'S JEWELRY STORE, C. 1915. James Beitel returned from serving in the Union army in 1863 and opened his first jewelry store at 215 Front Street. In 1910, Beitel, by now one of the most respected and influential men in Catasauqua, moved his store into the Lehigh National Bank, of which he was president. The business, carried on by his son, Robert, moved to 513 Front Street in 1951, taking with it the display cabinets and counters seen here.

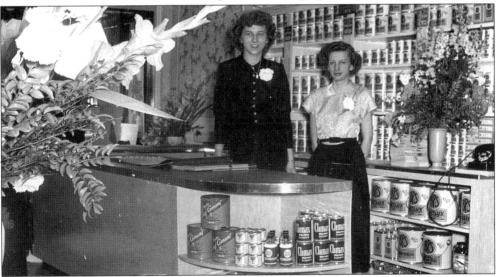

GILLETTE'S WALLPAPER AND PAINTS STORE, 1950. When the Philadelphia, Bethlehem & New England Railroad machinist John Gillette was idled by the Bethlehem Steel strike in 1949, he opened a paint and wallpaper store at 425 Front Street. Pictured on opening day in March 1950 are his daughter Elizabeth (right) and her friend Dolores Sauerzopf. An experienced handyman, Gillette could offer expert advice as well as the tools and materials for home beautification. Gillette closed the store in 1954 and became custodian of St. Mary's Church and School.

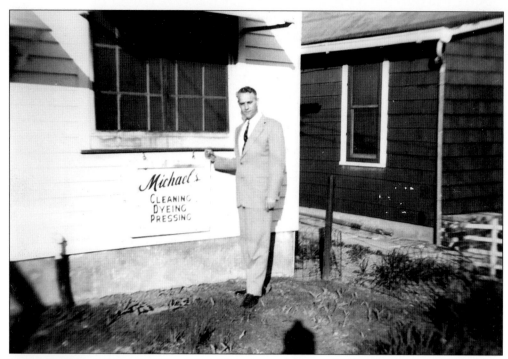

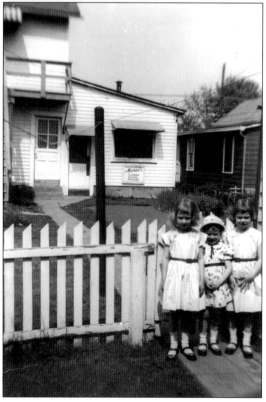

MICHAEL'S CLEANERS, C. 1953. Mike Nederostek opened his first dry-cleaning establishment behind his father's house at 28 Second Street in 1939. After returning from the army in 1945, he reopened in a small, two-story building behind his home, at 37 Second Street (above) and ran the business until 1966. His daughters are shown in front of the building in the mid-1950s (left). They are, from left to right, Ann, Collette, and Michelle.

Three

GETTING HERE

"There is probably no town in the whole Lehigh Valley so favorably situated for traveling facilities as Catasauqua," wrote the authors of the 1914 *History of Catasauqua*. At that time, they said, it took no more than 20 minutes to walk from anywhere in the boroughs to a train station or streetcar stop from which one could embark on a journey of thousands of miles.

Catasauqua is where it is because of the canal, which had enough of a current to drive the blowing engine for the iron mill. The canal also brought the coal that fired the furnaces and carried away at least some of the iron the mill made. When the canal could not meet the needs of the iron company, the Crane itself went into the railroad business, setting up the Catasauqua and Fogelsville Railroad to bring iron ore from the western Lehigh Valley. By 1900, there were six railroads serving the Iron Borough. The famous *Black Diamond* hurtled through every day, and for Catasauquans it was an easy train trip to New York, Scranton, Mauch Chunk, or Philadelphia for either business or pleasure.

The Crane built its own bridge as well, a wooden covered span that gave Bridge Street its name in 1845. There was a toll-free bridge that was used by townspeople as well as the company. But in 1904, the iron company replaced the covered bridge with the iron-and-stone trestle that still stands, and claimed its right to use it exclusively for its own trains. Undaunted, the people of Catasauqua quickly found the funds to build the first Pine Street bridge for their own use.

It has long been easy to get to and from Catasauqua; now the borough's proximity to the airport is a mixed blessing. Virtually no other community has such fast and easy access to air travel, but the airport's continued expansion may prove to be a challenge that Catasauqua cannot surmount.

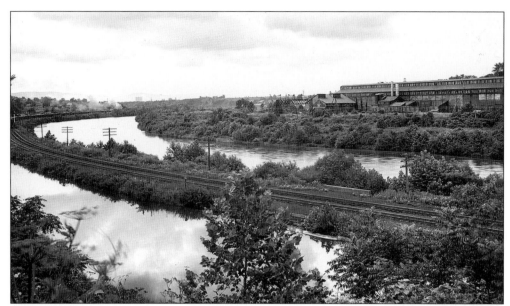

THE LEHIGH COAL AND NAVIGATION CANAL AND THE CENTRAL RAILROAD OF NEW JERSEY TRACK SOUTH OF CATASAUQUA. The Lehigh Car, Wheel and Axle Works is visible on the Fullerton side of the Lehigh.

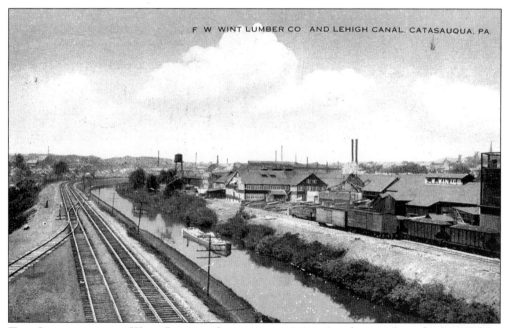

THE CANAL AND THE WINT LUMBER COMPANY, C. 1910. Lumber was brought from White Haven on the canal to a lumberyard at Front and Spring Streets as early as 1853. Ferdinand W. Wint bought into the business in 1866, and at various times the company operated a planing mill, a sawmill, a casket company, and offered custom kitchen cabinets. Wint Lumber was sold to the Butz Lumber Company of Palmerton on April 1, 1982, and on April 15, the day after the fire that destroyed the Wahnetah silk mill, a huge fire leveled much of the lumberyard. The casket company remained in family hands until the late 1980s.

DAM NO. 6 AND THE GUARD LOCK, LEHIGH RIVER, AND LEHIGH COAL AND NAVIGATION
CANAL. At the wing dam and guard lock in North Catasauqua (above), down-bound canal
boats could reenter the canal from the slack water area north of the dam. The same dam and
lock is shown in a picture taken in the early 1930s (below), looking west toward the Thomas
Iron Works in Hokendauqua.

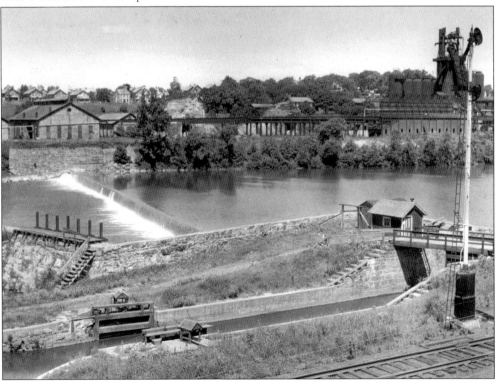

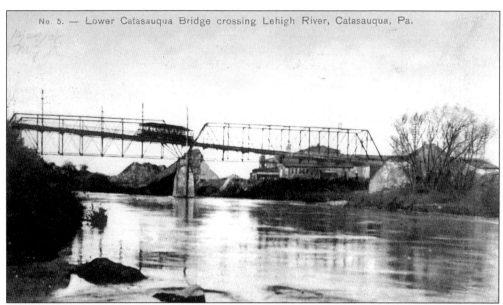

THE RACE STREET BRIDGE, C. 1900. The first chain bridge, Biery's Bridge, was built on this part of the river in 1824. A succession of privately owned bridges followed until 1892, when Lehigh County bought the 1863 bridge, tore it down, and with money from the Lehigh Valley Railroad (whose tracks the bridge crossed on the western bank of the river) and the Rapid Transit Company, erected this iron bridge with a wooden plank roadway. This bridge was closed in 1954 and replaced a few years later.

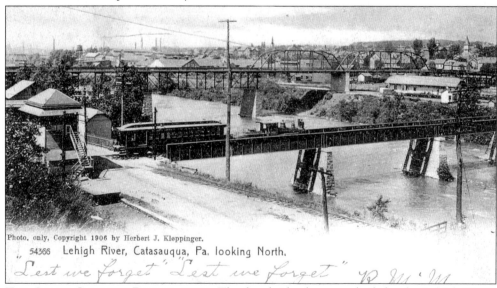

THE CRANE COMPANY BRIDGE, 1906. The first bridge here was built by the Lehigh Crane Company in 1845 to bypass the tolls on Biery's Bridge and to have a way to bring ore carts from the western part of Lehigh County directly to the ironworks—hence, the name Bridge Street. The original bridge was strengthened in 1857 to carry ore trains from the Catasauqua and Fogelsville Railroad, but that bridge was destroyed in the 1862 flood. The replacement bridge, which accommodated foot and carriage traffic as well as trains (despite being covered), was torn down in 1904 and replaced with the iron-and-stone trestle, which still stands.

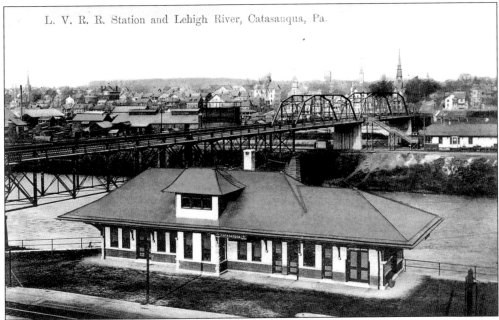

THE LEHIGH VALLEY RAILROAD'S CATASAUQUA STATION. The tracks of the Lehigh Valley Railroad reached the western end of the Lehigh Crane Bridge in the fall of 1855. For many years, a rather ragtag group of buildings served as a freight and passenger station until being damaged by a runaway train car in 1904. An attractive one-and-a-half-story brick building, considered "one of the finest small-town stations," replaced it in 1905. An iron staircase led from the platform (which still lies under the brush near the Pine Street bridge) to the steel Pine Street bridge, which opened in 1907.

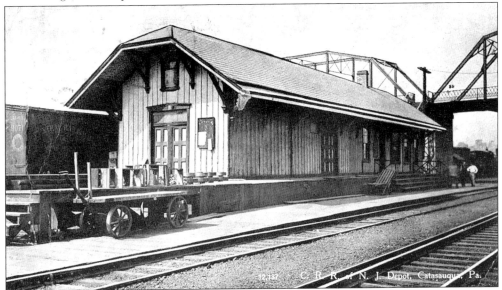

THE FREIGHT DEPOT, NEW JERSEY CENTRAL RAILROAD. This building stood on the Catasauqua side of the Lehigh, between the river and the canal, just north of the Crane Bridge. It was sold to the Wanamakers, Kempton, and Southern Railroad in the mid-1960s and is now the steam excursion line's station in Kempton.

35

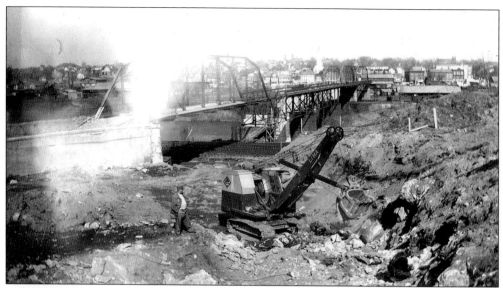

THE DEMOLITION OF THE 1907 PINE STREET BRIDGE, FEBRUARY 28, 1952. Both of these photographs, and those on the following two pages, were taken by an unknown amateur photographer. The old bridge had been condemned and closed in 1948, but it took until August 1951 to persuade the commissioners of Lehigh County to approve a new one. Disputes over funding delayed the start of the demolition until the following winter.

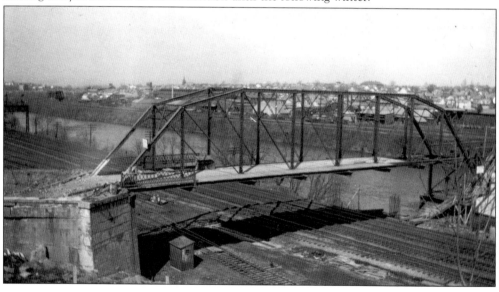

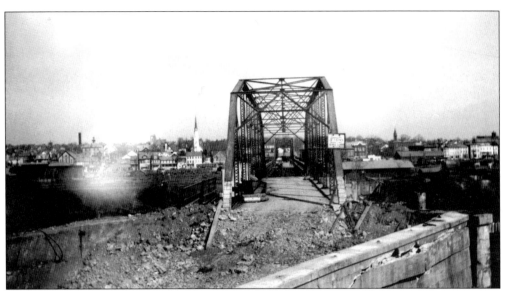

THE DEMOLITION OF THE 1907 PINE STREET BRIDGE. More demolition activity occurred on February 28, 1952 (above). On March 9 (below), the western steel structure of the bridge was lowered onto the tracks of the Lehigh Valley and Catasauqua and Fogelsville Railroads, where it was presumably cut up.

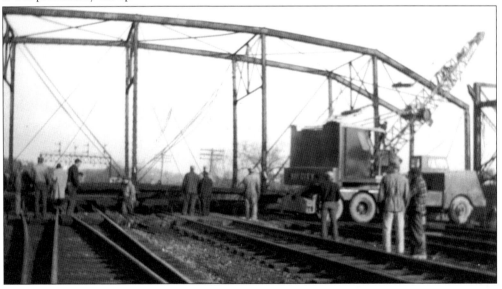

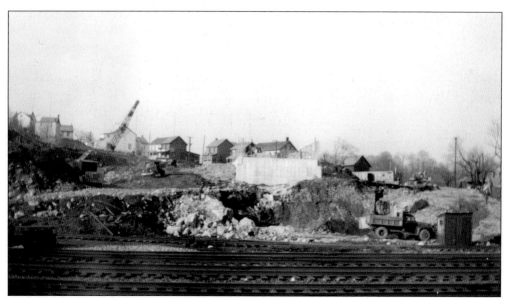

CONSTRUCTION OF THE PINE STREET BRIDGE. Construction of the new bridge by the G.A. and F.C. Wagman Company commenced, with this support on the western end going up on March 27, 1952 (above). The company's bid for the construction was $1.4 million. By April 19, several more supports were in progress (below).

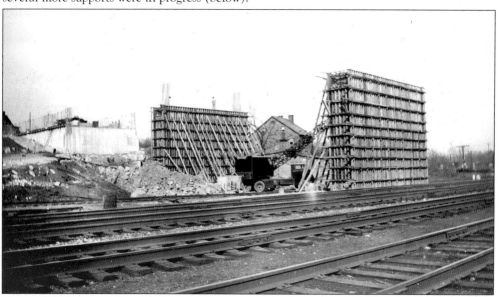

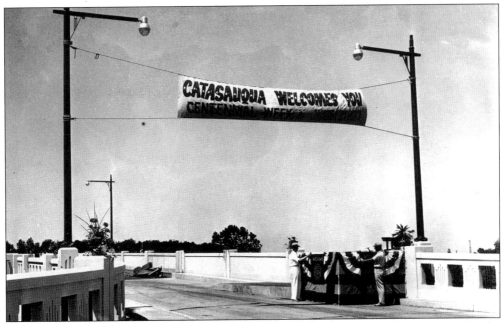

THE PINE STREET BRIDGE DEDICATION, JUNE 23, 1953. Borough workers prepare for the dedication (above), which was part of the centennial celebration, June 21–27. Dorothy Guzy, Miss Catasauqua, cuts the ribbon (below), surrounded by borough, county, and Whitehall Township officials.

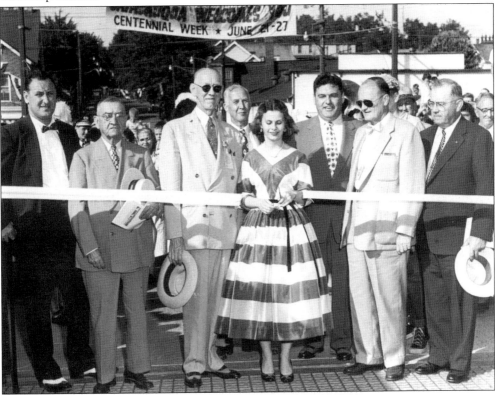

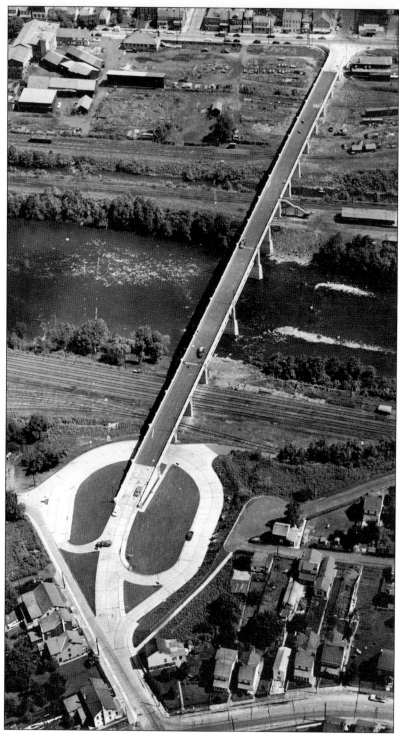

AN AERIAL VIEW OF THE PINE STREET BRIDGE IN THE MID-1950S. West Catasauqua is at the bottom of the picture, and Catasauqua is seen at the top. Several Front Street landmarks, including Wint's lumberyard, Heckenberger's drugstore, and the Savoy Theater, are visible.

40

Four

THE WALLS OF ZION

A Welsh hymn that has been sung in Catasauqua since its first days tells of the "peaceful walls of Zion." Both the life of the spirit and membership in a church have been important to Catasauqua's residents from the beginning. David Thomas built the first church in town, a small wooden building up the hill from his iron furnace, even before he completed work on the iron mill. Catasauqua's "walls of Zion" grew out of the zeal of both the wealthy industrialists and the poor immigrants who came to work in their industries. As each successive wave of new residents came to town, either from other parts of Pennsylvania or from foreign countries, they brought their ways of worship and their religious fervor with them. For a few generations, those unique identities persisted, usually by using the language of the founders on Sundays. Now, there is little trace of those ethnic origins, save for "Stile Nacht" at Christmas and paskha bread at Easter. However, "planted in faith and hope," as Samuel Thomas said at the 50th anniversary of the Presbyterian church in 1904, the churches and their congregations remain an unbroken link to the past.

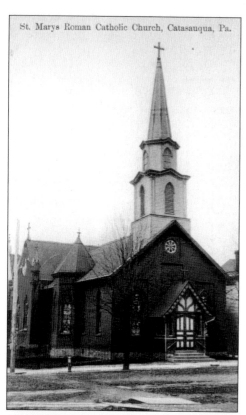

St. Marys Roman Catholic Church, Catasauqua, Pa.

St. Mary's Church, c. 1910 (Left) and in the Mid-1960s (Below). Annunciation of the Blessed Virgin Mary Parish, known as St. Mary's, was founded by St. John Neuman in 1857 for a congregation of German immigrants. The building (left) was constructed in 1878, replacing a smaller wooden church, and was enlarged in 1896. The present church (below) was built in 1927.

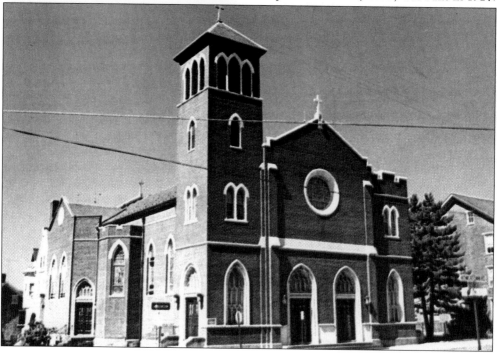

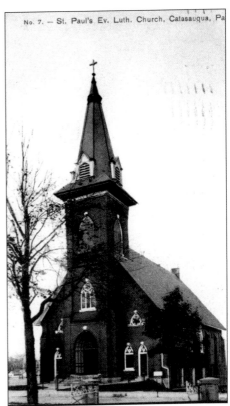

ST. PAUL'S LUTHERAN CHURCH, C. 1900 (RIGHT) AND IN THE MID-1960S (BELOW).
St. Paul's was organized in 1851, and the first church was built on the site of the present one in 1852. The present building dates from 1888, though somewhat altered inside and out, including restoration after a fire in March 1979. Like St. Mary's, the original congregation of St. Paul's was German, and the language was used in at least some services until well into the 20th century. From 1867 to 1978, St. Paul's had only three pastors: J.D. Schindel (1867–1888), James F. Lambert (1892–1944), and Philip Miller (1944–1978).

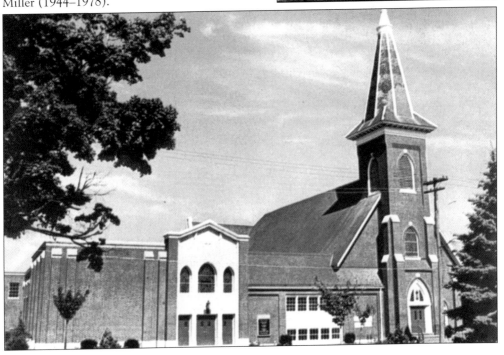

43

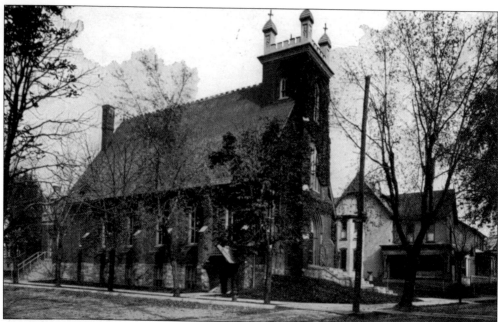

THE HOLY TRINITY LUTHERAN CHURCH, C. 1890 (ABOVE) AND IN THE MID-1960S (BELOW). The English Lutheran Church of the Holy Trinity, as it was originally titled, was founded in January 1873 by a group of second-generation members of St. Paul's who had been rebuffed in an attempt to switch to English for church services. The new congregation broke ground for a church at Third and Bridge Streets later that year; it was dedicated on May 17, 1874. In 1926, the daughters of Mr. and Mrs. Oliver Williams donated money to build the present church at Fourth and Pine Streets as a memorial to their parents. The former church became the Public Library of Catasauqua in 1926.

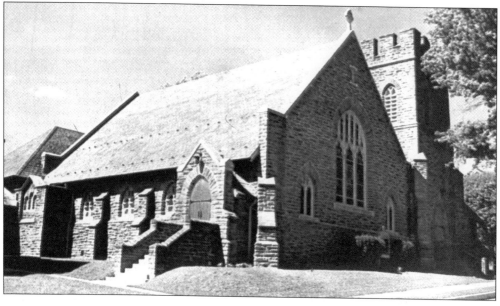

THE SALEM UNITED CHURCH OF CHRIST, AS THE SALEM REFORMED CHURCH, C. 1900 (RIGHT) AND IN THE MID-1960s (BELOW). Salem has perhaps the most complex history of any congregation and church building in Catasauqua. Begun in 1852 as a union church with local Lutherans, Salem's Reformed congregation struck out on its own and built the church at Third and Walnut Streets in 1869; then, it was known as the First Reformed Church. A dispute nearly caused the dissolution of the congregation shortly afterward, and the building was leased to several different groups for worship. Reconstituted in 1873, the church went bankrupt in 1880, partly due to the steeple's collapse in a storm. A determined group bought back the church and, by 1887, the church was self-supporting. By 1910, Salem had one of the largest congregations in town. The church was affiliated with the United Church of Christ in 1957, and the exterior was refaced in 1963.

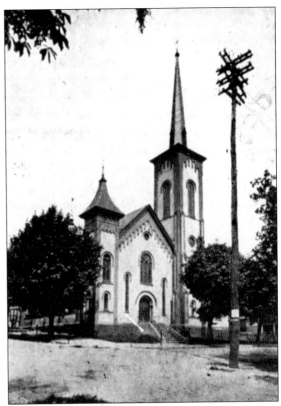

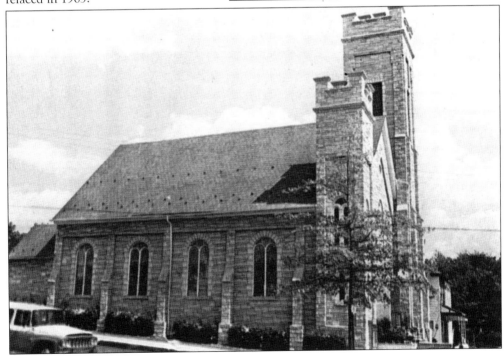

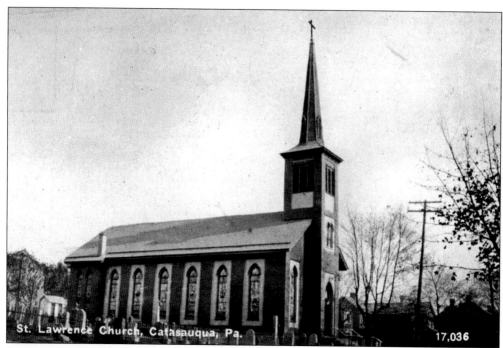

St. Lawrence Church, Catasauqua, Pa. 17,036

ST. LAWRENCE'S ROMAN CATHOLIC CHURCH, C. 1900 (ABOVE) AND IN THE MID-1960S (BELOW). The English-speaking Catholic church for Catasauqua was built in 1857 and was vandalized the following summer, in what is perhaps the only recorded instance of sectarian bigotry in the two boroughs. The church retained its original appearance until 1924, when a visit to California by the pastor inspired an exterior renovation in Spanish-Mission style. St. Lawrence's is the only church in town that retains a cemetery (albeit an inactive one) on the property.

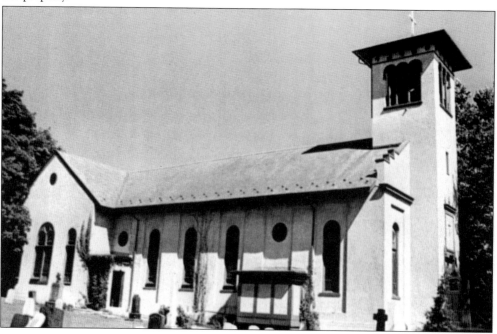

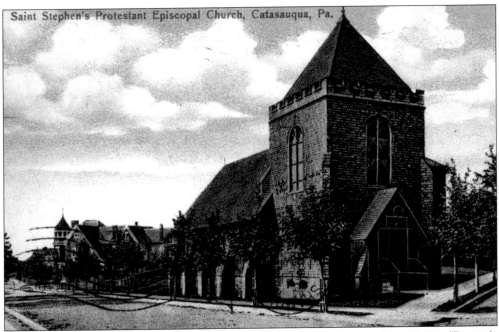

Saint Stephen's Protestant Episcopal Church, Catasauqua, Pa.

ST. STEPHEN'S EPISCOPAL CHURCH, C. 1909 (ABOVE) AND IN THE MID-1960S (BELOW). Episcopalians in Catasauqua worshiped in a variety of places, including the Lehigh Valley Railroad Station from 1870 until Leonard Peckitt donated the land at Howertown and Walnut Streets for a church in 1900. The church, modeled on an ancient chapel at Canterbury Cathedral, was used from 1901 until 1975. When St. Stephen's relocated to Whitehall, the Catasauqua Women's Club bought the building and met there until 1995. For a time, it was a private home. Today, it is the Between Two Hearts Bridal Shop.

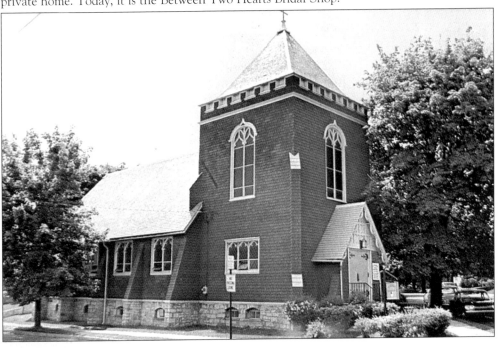

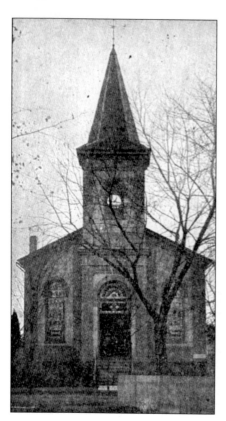

THE BRIDGE STREET PRESBYTERIAN CHURCH, c. 1910. This building, no longer in existence, was built *c.* 1866 and stood on Bridge Street, opposite the intersection with Fourth Street. The English-speaking Scotch-Irish Presbyterian Ulstermen who came to work in the iron mills and foundries were a different nationality and social class than the owners and executives who worshiped in Welsh with David Thomas in the Presbyterian Church on Pine Street. Dedicated to education, the church ran a private school at Howertown and Bridge Streets from 1849 to 1856. By 1914, more public college graduates came from this congregation than any in the borough. The Presbyterian churches merged in 1937.

THE PRESBYTERIAN CHURCH IN THE MID-1960s. No other institution still in existence is more closely tied to town history than this church. David Thomas built the first Presbyterian church in 1839, a small building on Church Street, even before he completed his first blast furnace. In 1856, he donated the land across Pine Street from his new home, and the present church was built. A steeple was erected by Cain Semmel in 1871, and numerous memorial stained-glass windows, including a Tiffany, were installed over the years. To celebrate the church's centennial in 1956, electric utilities magnate Frank Tait and his wife and sister-in-law set up a fund to illuminate the steeple and windows.

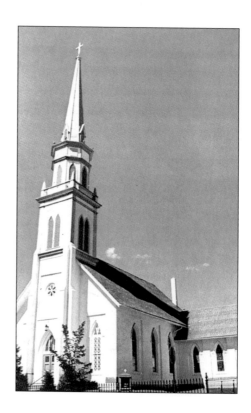

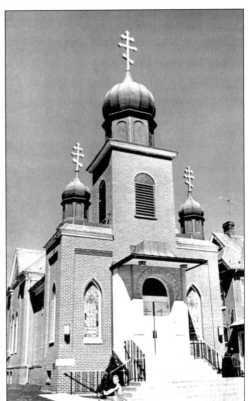

THE HOLY TRINITY ORTHODOX CATHOLIC CHURCH, C. 1910 (RIGHT) AND IN THE MID-1960s (BELOW). Reputed to be one of the oldest Orthodox churches in the United States, Holy Trinity was founded in 1899 by the Russian missionary bishop St. Tikon to minister to the spiritual lives of new immigrants from Eastern Europe. Major renovations and beautification, particularly a new icon screen, were installed in the 1980s.

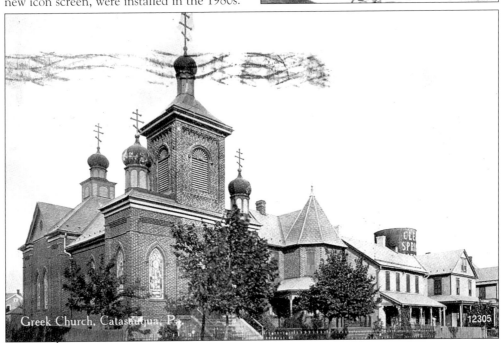

Greek Church, Catasauqua, Pa.

12305

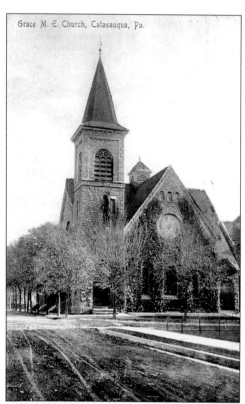

Grace M. E. Church, Catasauqua, Pa.

THE GRACE METHODIST CHURCH, C. 1900. Methodist services were conducted in Catasauqua as early as 1843, but the congregation did not have a home until purchasing a lot at 709 Front Street from James W. Fuller Sr. By Christmas of 1859, church members had completed the basement of the building still standing on that site. As befell their brethren at Salem, the costs of completing the building were too much, and the church was bought at a sheriff's sale by Tilghman Meyers, who with generous support from the Fullers, gave it back to the congregation. After that low point, the congregation flourished and, in 1890, sold the Front Street building to the Odd Fellows Lodge and built the present church at Fifth and Walnut Streets.

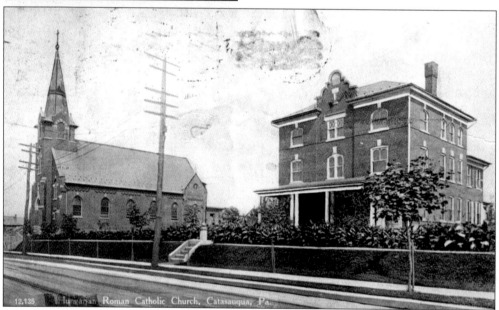

12,135 Hungarian Roman Catholic Church, Catasauqua, Pa.

ST. ANDREWS SLOVAK CATHOLIC CHURCH, C. 1910. St. Andrew's parish was formed in 1902, and the church, built at a cost of $25,000, was dedicated the following year. Like Holy Trinity Orthodox, parishioners for St. Andrew's came from many communities outside Catasauqua. In 1914, the church had over 1400 members. Though essentially Roman Catholic, parts of the liturgy were performed in the Slovak language until well into the 1960s.

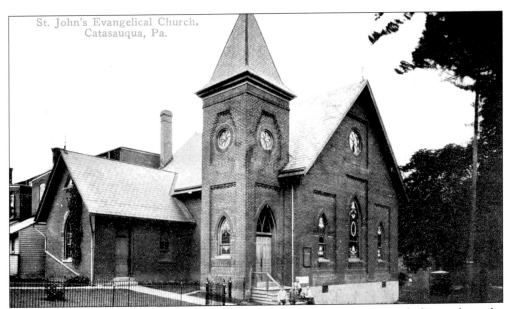

ST. JOHN'S EVANGELICAL CHURCH, C. 1910. This congregation was formed after a split in the Evangelical Association in 1894, and the church was built on Walnut and Limestone Streets the following year. Later known as the Evangelical Congregational Church, St. John's dissolved in the 1970s. Several other religious congregations used the building for a time, but it has been a private residence since the early 1990s.

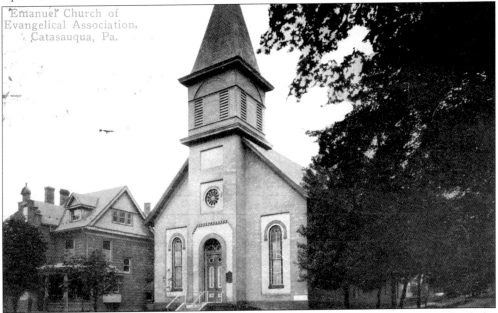

EMMANUEL EVANGELICAL CHURCH, C. 1900. Originally known as Immanuel Evangelical, the congregation formed in 1848 as the Evangelical Association of Catasauqua. Their first church, called a meetinghouse, stood on Howertown Road below Mulberry. Having outgrown that building, the congregation erected a church at Second and Walnut Streets in 1868. Though the breakup of the Evangelical Association was a severe blow, the congregation continued until the late 1960s. The building is now a private residence.

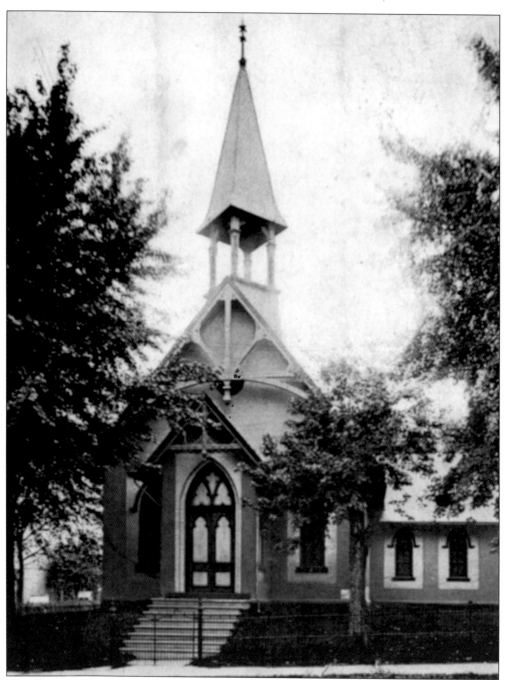

The Bethel Welsh Congregational Church, Fourth and Pine Streets. The only religious organization in Catasauqua to have disappeared without a trace, leaving neither building nor records behind, the Welsh church relied entirely on a benefactor, Elizabeth Thomas, who was known as Mother Thomas. The wife of David Thomas, she empathized with those in town who longed to worship in Welsh, and contributed the land and much of the funding for the church. Though permanently debt-free, the congregation had dwindled to fewer than 20 members by 1914, and disappeared soon afterward. Holy Trinity Lutheran Church occupies the site now.

Five

THINKING AND
LEARNING TO THINK

Despite their wealth, the millionaires of Catasauqua apparently had little taste for the cultural trappings that many other American entrepreneurs took up, largely as a way to insinuate themselves into old-money genteel society. Perhaps it was because these wealthy Welshmen were Catasauqua's high society; perhaps it was just because they were so focused on their businesses that they paid no attention to such things as art or music. So Catasauqua never had an opera house, though there were numerous singing societies, a custom brought from Wales. Although there were lectures and "improving" seminars, the library was not founded until 1923 and had to find housing first in a storefront and then in an abandoned church.

But one thing the fathers (and mothers) of Catasauqua took seriously was education. Even before Pennsylvania passed child-labor and mandatory education laws, Catasauqua boasted a number of publicly funded elementary schools. Catasauqua started the first public high school in Lehigh County and regularly built and improved its schools—a process that was every bit as contentious then as it is now. Catasauqua schools were the first in Lehigh Valley to use slate chalkboards in classrooms, and a continuing education program for teachers was begun in the 1870s. North Catasauqua, though smaller and unincorporated, had its own school district for many years. Much of the communities' lives revolved around the schools for social and athletic pastimes, as well as academics. Going through Catasauqua schools has been a key part of Catasauquans' identities for many years. Even today, many children find themselves being taught by the same teachers who instructed their parents. This has made for yet another powerful link with the past.

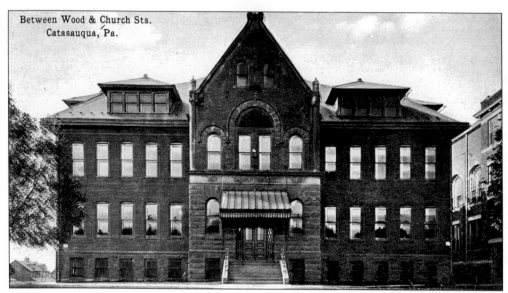

Between Wood & Church Sts.
Catasauqua, Pa.

LINCOLN SCHOOL, C. 1900. The original Lincoln School had 10 classrooms and cost $35,000 to build in 1896. It was constructed to replace the school that stood from 1868 to 1898 on the west side of Front Street at Willow Alley. That building was crowned with a four-sided clock tower, which is visible in many old pictures of the iron works. But many people believed that the location, adjacent to the blast furnaces, was unsafe for students. Lincoln School burned down on September 23, 1940, taking with it the complete records of the school board from its start in 1856 and 70 years worth of the *Catasauqua Dispatch* newspaper.

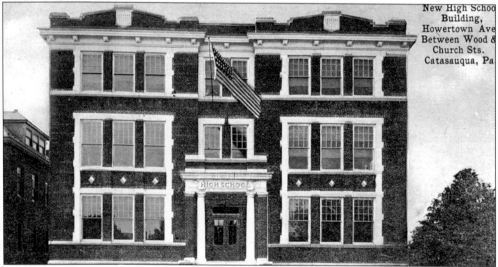

New High School
Building,
Howertown Ave
Between Wood &
Church Sts.
Catasauqua, Pa

THE NEW HIGH SCHOOL, C. 1914. By 1912, the number of students going beyond elementary school exceeded the capacity of the original high school at Second and Walnut Streets. The new high school building, with space for 250 pupils, was constructed next to Lincoln School after many heated arguments over location, cost, and the wisdom of adding to the school district's debt load. When put to a town-wide vote, the people of Catasauqua voted in favor of the new school. The high school boasted a chemistry lab, basement gymnasium, and commercial classroom with 10 typewriters. This building still remains as the north wing of Lincoln Middle School.

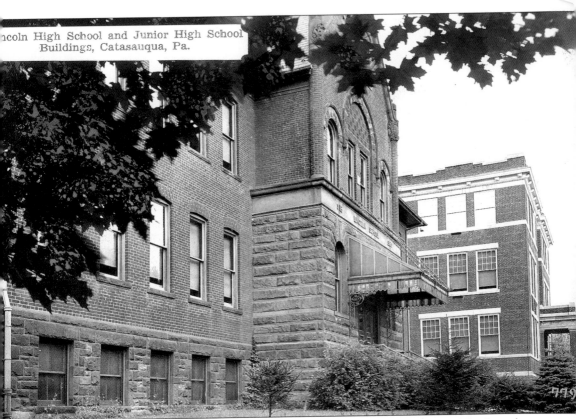

lncoln High School and Junior High School
Buildings, Catasauqua, Pa.

A VIEW OF LINCOLN SCHOOL AND THE HIGH SCHOOL IN THE MID-1930S. The Lincoln School burned down in September 1940, a fire that may have been arson. After being rebuilt in 1942, the entire complex on Howertown Road became the junior-senior high school. Teachers, too, were taught in these buildings. Teachers were offered biweekly, after-school classes like Methods of Teaching and Thinking and Learning to Think.

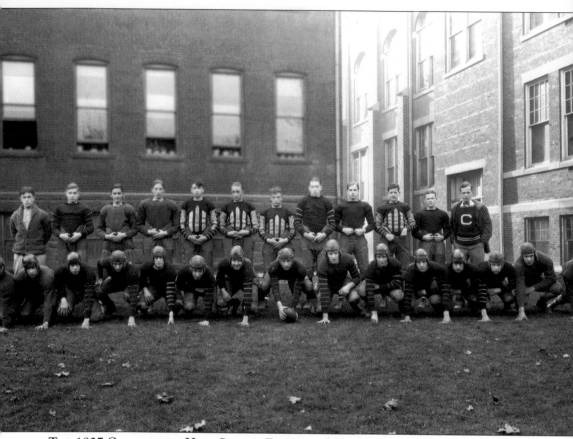

THE 1927 CATASAUQUA HIGH SCHOOL FOOTBALL SQUAD, IN FRONT OF LINCOLN SCHOOL.
Beaten only once, the team allowed only 25 points, while scoring 137. Shown here are, from
left to right, the following: (front row) Bill McKeever, Charles Keim, Reynold Young, Luther
Coris, Robert Young, Cliff Woodring, Stuart McFetridge, James Samuels, Ralph Walker, and
Paul Woodring; (back row) Coach Steven Steger, Roger Rohn, William Stirling, James
Gillespie, Edwin ?, Robert Manley, Donald Oswald, Marshall Clauser, Franklin Winters,
Donald Douglas, James Tosh, and Edwin Koons.

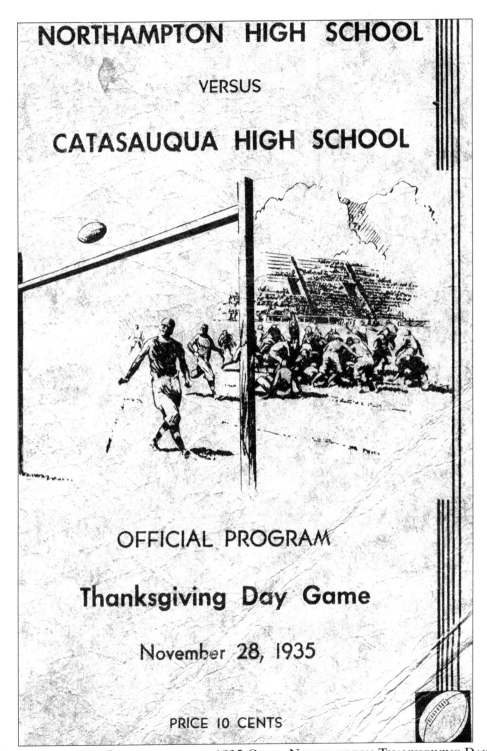

NORTHAMPTON HIGH SCHOOL

VERSUS

CATASAUQUA HIGH SCHOOL

OFFICIAL PROGRAM

Thanksgiving Day Game

November 28, 1935

PRICE 10 CENTS

THE COVER OF THE PROGRAM FOR THE 1935 CATTY-NORTHAMPTON THANKSGIVING DAY FOOTBALL GAME. This was the 13th clash in a series that has become one of the oldest high-school rivalries in Pennsylvania.

THE SECOND STREET SCHOOL, LOCATED AT SECOND AND WALNUT STREETS. This was the original Catasauqua High School and the first public secondary school in Lehigh County. Built in 1868, it was used as the high school until 1912 and as an elementary school until 1961. It is now a playground.

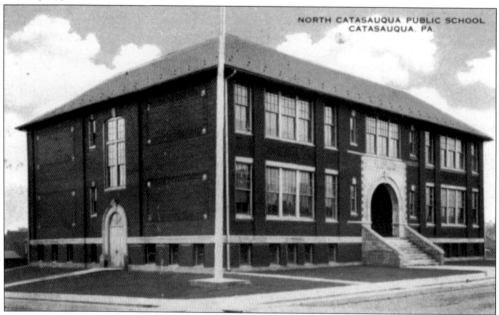

NORTH CATASAUQUA SCHOOL, BUILT IN 1913. North Catasauqua had its own school district until 1953. Grades one to eight and kindergarten were taught in its 10 rooms. For high school, pupils went on to either Catasauqua or Whitehall High Schools. After the school districts were merged into the Catasauqua Union School District in 1953, North Catasauqua School housed kindergarten through grade six until 1972. In 1975, the building became the borough hall for North Catasauqua, and it was completely refurbished in 1995.

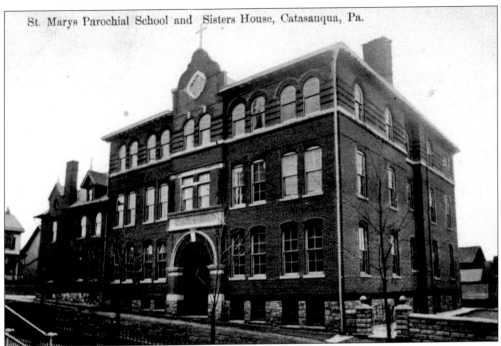

St. Marys Parochial School and Sisters House, Catasauqua, Pa.

ST. MARY'S SCHOOL AND CONVENT (ABOVE) AND ST. LAWRENCE'S SCHOOL (BELOW).
St. Mary's School and Convent were built in 1903 to replace a two-room school that had stood
on the site at Second and Union Streets since 1882. St. Lawrence's school was built in 1905
and housed commercial studies classrooms, which were open to students of all ages and faiths,
as well as an elementary school. Both St. Mary's and St. Lawrence's Schools were staffed by the
Sisters of the Third Order of St. Francis from Glen Riddle. After 1970, the order could no
longer staff the schools, so they were merged and operated until 1978.

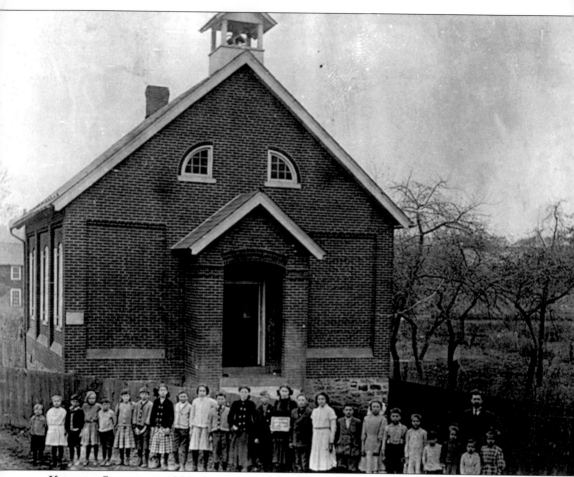

KOEHLER SCHOOL, C. 1928. A one-room schoolhouse, Koehler School stood on the canal road at Lock 37, the remains of which are still visible in the park at Catasauqua Lake. Built in 1897 to replace a stone one-room school that had stood across the road since 1852, the second Koehler School was used until 1932. This picture is believed to date to the late 1920s. The building became a private residence and was demolished in 2001.

Six

PUBLIC SPACES AND GATHERING PLACES

Once there was a time when the sidewalks of Catasauqua were thronged with people, especially on Friday and Saturday nights. There were places to go, hometown beer and soda to drink (though no respectable saloon ever admitted women, and no respectable woman would enter one), news and gossip to catch up on, and friends, relatives, and acquaintances to see and be seen with. A weekly event was the blowing out and banking of the iron furnaces on Saturday night—the flaring gases and showers of sparks never failed to attract a crowd on Front Street to witness the spectacle.

What we now call social support permeated life in Catasauqua. Besides the social life created by the churches, there were dozens of fraternal organizations, civic groups, political associations, sports teams, and women's leagues that met regularly, providing everything from intellectual stimulation, political fellowship, patriotic activity, enhanced work skills, and athletic competition to schoolhouse flags and burial insurance. This strong identification with the community has left a heritage of gathering places today, such as the playgrounds and pool. Although changing times have shut down many old organizations, the urge to gather is strong. New organizations have grown up, such as the YMCA, and the recreation areas are as popular as ever. And more than 20 years after the Arlington Hotel, with its sheltering porch, was torn down, neighbors still sit on a bench on Eugene Street, catching up, seeing, and being seen.

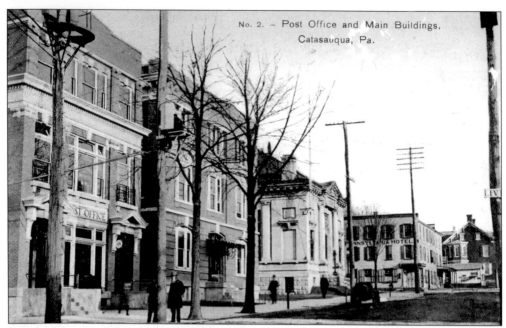

No. 2. – Post Office and Main Buildings,
Catasauqua, Pa.

DOWNTOWN CATASAUQUA, C. 1910. After 1900, the commercial and financial hub of Catasauqua had shifted up from Front Street to Second and Bridge Streets, where the bank, post office, and iron company headquarters were built within seven years of each other on the same half block. Also within one block were two hotels, the newspaper office, another bank, and several stores.

THE AMERICAN LEGION POST 215, 330 SECOND STREET, THE MID-1930S. The American Legion post was organized on July 7, 1919, and its home was built in 1924. The memorial tablet was erected in 1928 on the 10th anniversary of Armistice Day.

THE POST OFFICE, 122 BRIDGE STREET.

A post office was established in Biery's Port in 1844, but apparently was not housed in a dedicated building until this structure (right) was built in 1907. Two years later, mailmen began to walk the streets, making two deliveries a day to homes and three to businesses. There were 35 drop boxes scattered around town, as well. At various times, the post office shared this building with the telephone exchange and the Clear Springs Water Company. Col. James W. Fuller bought the building before his death in 1929, and it became Fuller Company offices in 1935. Designated Fuller Building No. 2 until 1976, it was torn down in the late 1970s. The present post office (below), at Second and Bridge Streets, was dedicated on November 23, 1935. This photograph was apparently taken from an upper story of the Pennsylvania Hotel, which stood across Bridge Street, and may have been shot before the building opened.

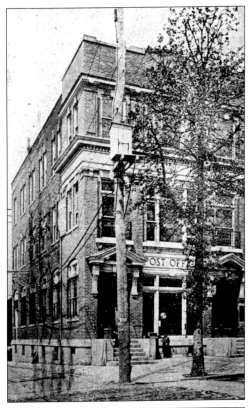

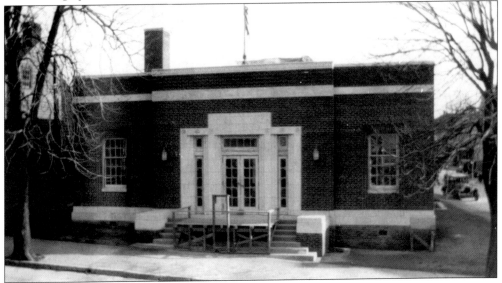

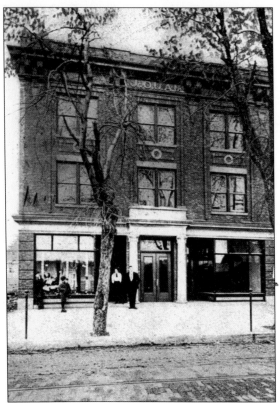

THE JUNIOR O.U.A.M. HALL (LEFT) AND THE ODD FELLOWS LODGE (BELOW). The Odd Fellows Lodge No. 269 was the oldest fraternal organization in Catasauqua, formed here in 1847. In 1890, the lodge purchased the former Grace Methodist Church, at 709 Front Street, and remained there until the they disbanded. The Junior O.U.A.M. was a patriotic fraternal organization that began in Catasauqua in 1881. It was dedicated to Bible reading in public schools and flying flags over them. This building now houses the LCB Wine and Spirits Store; the former Moose Lodge upstairs is now a Syrian social club.

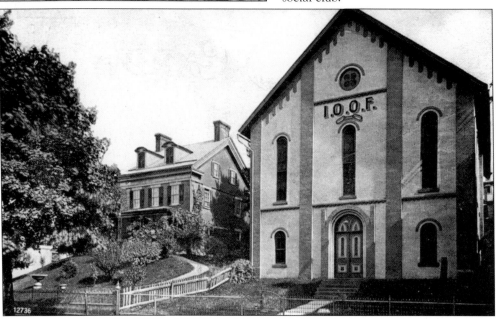

THE CHAROTIN HOSE COMPANY, SIXTH AND ARCH STREETS. When North Catasauqua became a borough in 1908, sentiment immediately turned towards having its own fire department. By 1911, the Charotin Hose Company built this station, which doubled as a borough hall for many years. In the late 1980s, the fire company moved into a new building next to borough hall on Fourth Street, and this building was demolished.

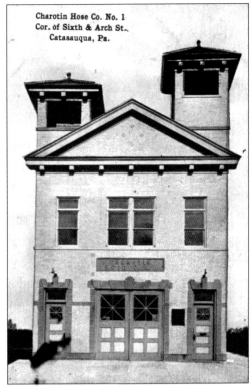

Charotin Hose Co. No. 1
Cor. of Sixth & Arch St.,
Catasauqua, Pa.

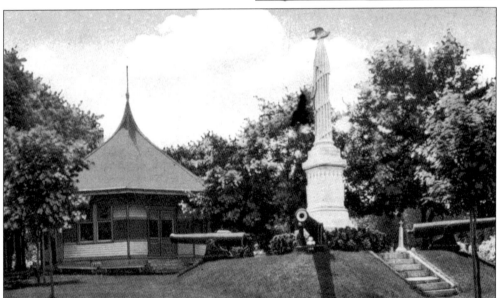

THE SOLDIER'S MONUMENT AND PAVILION, FAIRVIEW CEMETERY. The names of 157 Catasauquans who went off to fight for the Union are inscribed on the sides of the monument, which was the first Civil War memorial built in Pennsylvania. The monument is surrounded by four pre–Civil War guns, two British cannons dating from 1812 and two American guns dated 1819 and 1829, which were given to the Catasauqua post of the Grand Army of the Republic and added to the monument in 1871.

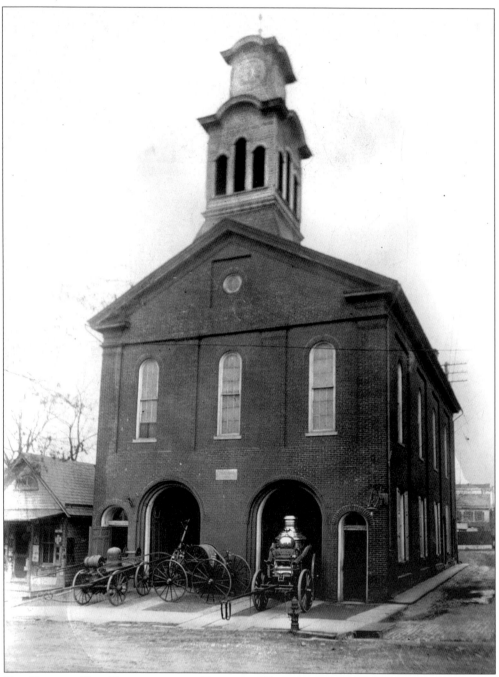

THE PHOENIX FIRE COMPANY, WITH BOROUGH HALL ON THE SECOND FLOOR. The fire company was organized in 1866, and its first hand-operated pumper is on the left in this picture. In 1868, a new borough hall was built on the north side of Church Street in the block between Front and Second Streets, and the Phoenix moved into the first floor. This picture was taken c. 1910. The small building to the left, which no longer exists, was the first office of the *Catasauqua Dispatch* newspaper. This building remained borough hall until the 1980s, when it was converted to apartments.

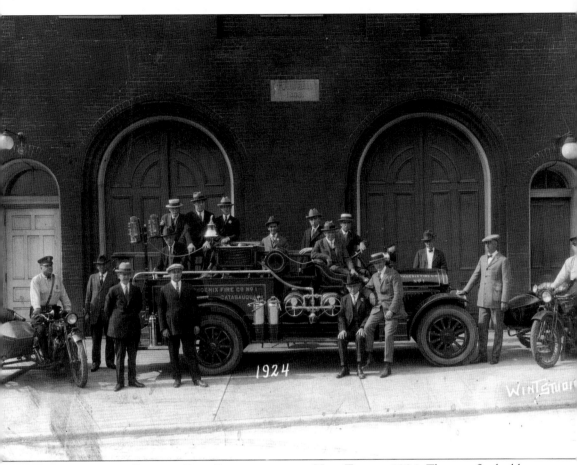

MEMBERS OF THE PHOENIX FIRE COMPANY WITH A NEW TRUCK, 1924. They are flanked by Catasauqua's two policemen.

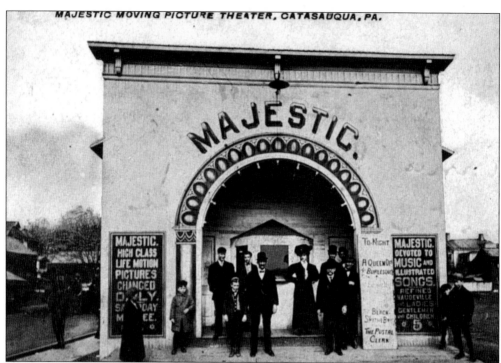

THE MAJESTIC THEATER, C. 1910 (ABOVE) AND C. 1914 (BELOW). William Wentz was described in his obituary as "a pioneer exhibitor in the motion picture industry." In 1906, Wentz opened a "nickolet," an early movie theater that charged a 5¢ admission fee, with his brother-in-law, Frank Young, in Catasauqua. Three years later, they built the Majestic at Front and Pine Streets. In 1914, they expanded the theater and enclosed the lobby.

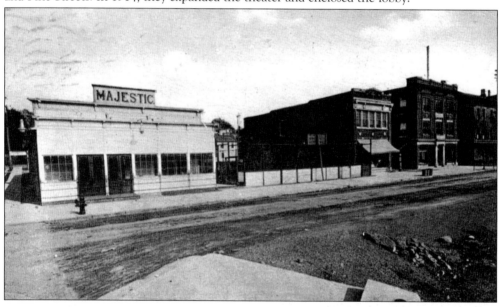

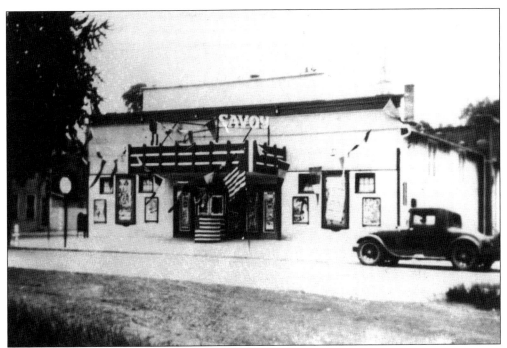

THE SAVOY THEATER, THE MID-1920S AND THE LATE 1940S. The theater was sold and renamed the Savoy in 1922 (above). With Edgar's Drug Store next door, and Heckenberger's across Pine Street, moviegoers did not have to go far for a soda fountain treat after the movies. Over the next two decades, renovations were made, but the theater building retained many of its 1914 dimensions (below). The Savoy closed in 1962 (the last two movies shown were Hitchcock's *Psycho* and Disney's *The Parent Trap*) and was torn down shortly afterward. A Mobil station now stands on the site.

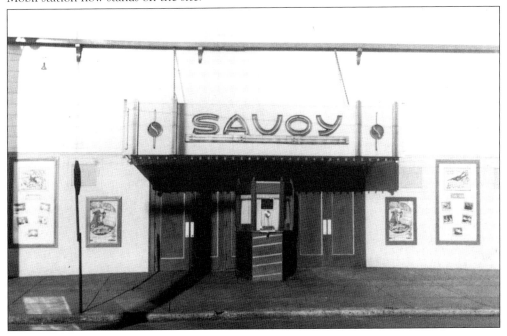

THE PALACE THEATER, FRONT AND WALNUT STREETS. The interior of the Palace Theater, a contemporary of the Majestic, is shown on this extremely rare postcard; on the back it reads, "Palace Theater on a Dull Night—Compliments of Manley and Roxbury." William Manley was part owner of the theater. The Palace opened in 1912. When it closed is unknown, but the building became the Varsity restaurant, which was a classic high-school hangout in the 1940s, and it currently houses the Body Clinic.

THE THOMAS ATHLETIC FIELD, ST. JOHN AND WALNUT STREETS, C. 1935. This field at the north end of the playgrounds was the athletic grounds for Catasauqua High School until Alumni Field was built in the early 1970s. It was named in honor of William R. Thomas Jr., president of the Wahnetah Silk Mill, and his wife, Minnie Milson Thomas, who were generous patrons of the playgrounds. Note the near absence of houses on St. John Street to the left.

BUCK'S RESTAURANT, 713 FRONT STREET. It is not known who the owners of Buck's were or when these pictures were taken, but the restaurant was the headquarters for the Hanna Athletic Club, which fielded renowned amateur baseball and football teams for Catasauqua. The group below is probably a Hanna Athletic Club team out of uniform.

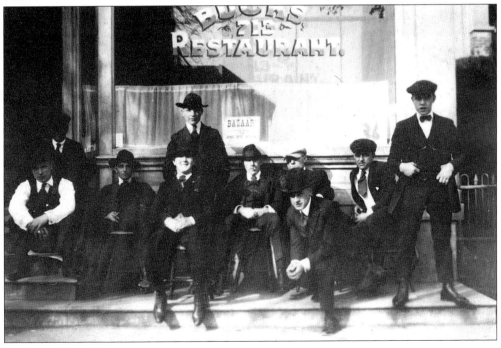

THE SWIMMING POOL, BATHHOUSE, AND LARGE PAVILION AT THE PLAYGROUNDS IN THE LATE 1930S. Catasauquans cavorted in this area for many years before it was developed as a park and playground in 1916. At that time, a dam was built in the Catasauqua Creek to make a swimming area. In 1933–1935, the 150-foot-long pool and bathhouse were built and the playground renovated as a Works Progress Administration project (above). The bridge in the foreground (below) was removed in the late 1960s when the rear fence of the pool area was moved 100 yards to the north to expand the seating area.

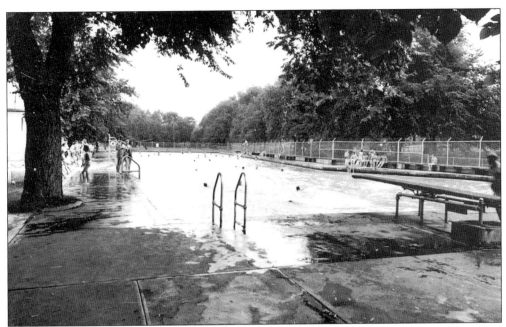

VIEW OF THE POOL FROM THE DEEP END, C. 1960. Still in its original state and still painted green at this time, there were two low boards and one high board in the diving area (above). The pool was renovated for the first time between the 1967 and 1968 seasons. The trough that had been recessed in the pool wall was removed, new edges, walls, and a floor were built, and the inside of the pool was painted light blue. The diving area was deepened to 12 feet, and new diving boards installed (below). In the bathhouse, the locker rooms were modernized and toilet facilities improved. The pool kept this configuration until being rebuilt again between the 1997 and 1998 seasons.

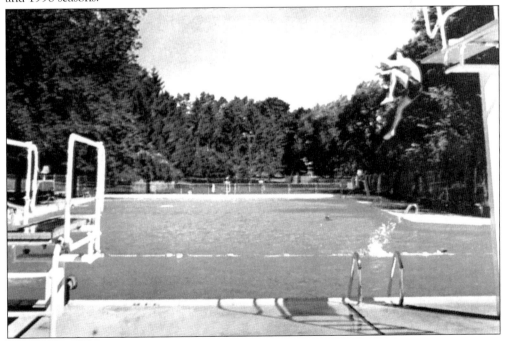

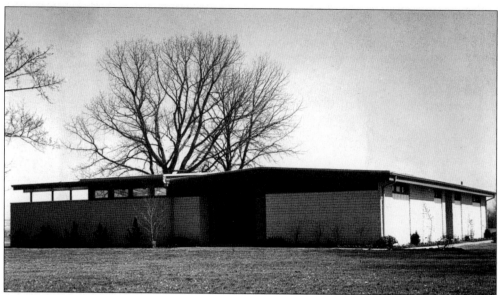

WILLOW BROOK GOLF COURSE. This is how the new clubhouse looked when it opened in 1963 (above). The course had to be renumbered and several traps removed to accommodate the new facility. The original golf course was a private five holes built by James Fuller on his estate off Howertown Road in the early 1920s; it fell into disrepair after his death in 1928. Four years later, optometrist Calvin Miller leased the original course and an additional 32 acres from Mrs. Fuller and constructed a nine-hole private course, which opened on October 1, 1932. In 1934, the Millers opened the course to the public, making it the second public links in Lehigh County. The view below was taken looking north from the Willow Brook clubhouse. The area immediately in front of the house and visible in the distance was added to the course in 2001, part of an expansion that extended the course to 18 holes.

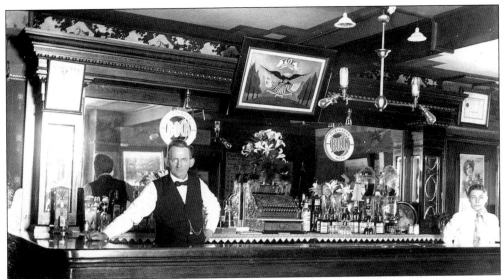

THOMAS HOWER, BEHIND THE BAR OF HIS SALOON. This may have been at 607 Front Street. With two breweries and dozens of hotels and barrooms, Catasauquans did not have to walk far for a drink in 1900. However, there was also a strong temperance movement, dating back to the arrival of the teetotaling ironmaster David Thomas. Male opponents of alcohol could join one of two temperance societies (there is no record of a women's group) and even, at one time in the mid-19th century, stay at a temperance hotel.

AUGUST HOHL'S WHOLESALE LIQUOR STORE, FRONT AND RACE STREETS, 1914. August Hohl converted the basement of his house at Second and Race Streets to a bottling plant in 1888. By 1901, his business had grown and expanded into wholesale liquor and soft drinks, and he bought this building across from the American Hotel to house a bigger bottling plant and a liquor store.

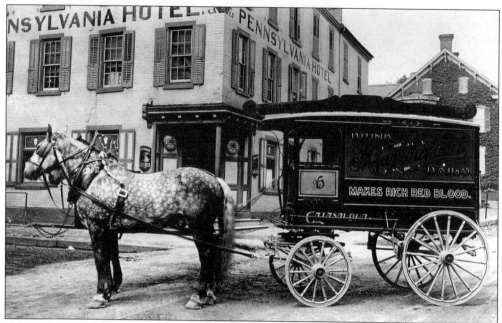

HOHL'S DELIVERY WAGON AT THE PENNSYLVANIA HOTEL. Hohl's trade extended far out of Catasauqua, but the core of his business was in town. His delivery wagon is seen in front of the Pennsylvania Hotel (above) where his wares—and Kostenbader's beer—were served up by proprietor John Geiger (below), seen here with one of his children and a barman.

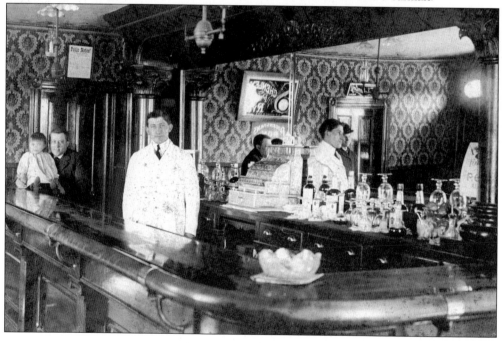

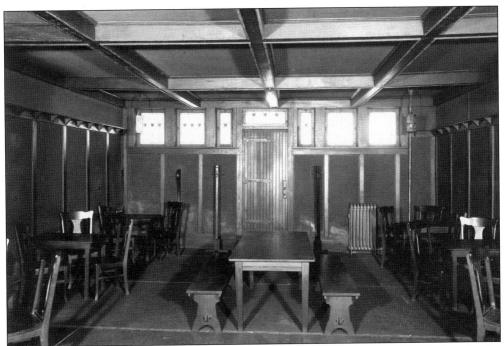

THE RATHSKELLER AND KITCHEN, PENNSYLVANIA HOTEL. In 1909, John Geiger bought the tobacco shop on Second Street next to his hotel and converted it into a rathskeller, which offered darts, among other amusements (above). Somewhat less appealing is the kitchen (below); despite this, the Pennsylvania Hotel had a good reputation for seafood in its last years.

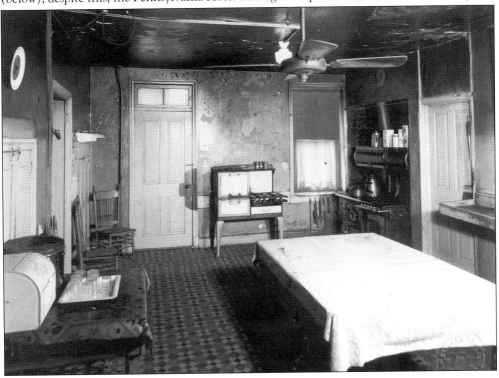

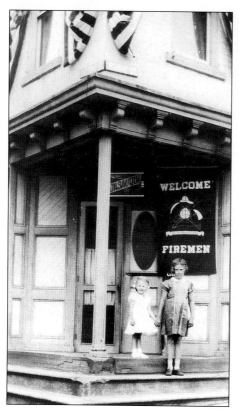

TWO YOUNG GEIGER GIRLS ON THE FRONT PORCH OF THE PENNSYLVANIA HOTEL, JUNE 1937. The banner (left) welcomes firemen to a parade that was held in Catasauqua that month. The hotel (below) is pictured shortly before being torn down in the late 1940s. For a time, an American Stores (forerunner of Acme) grocery used some of the space on the Bridge Street side of the hotel.

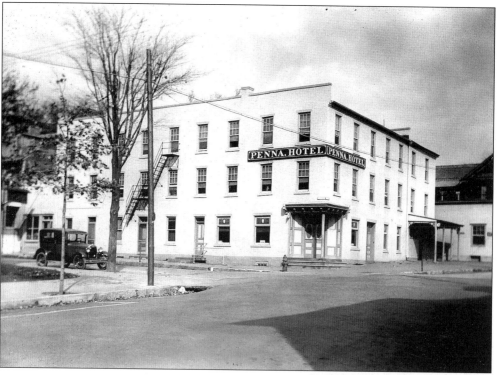

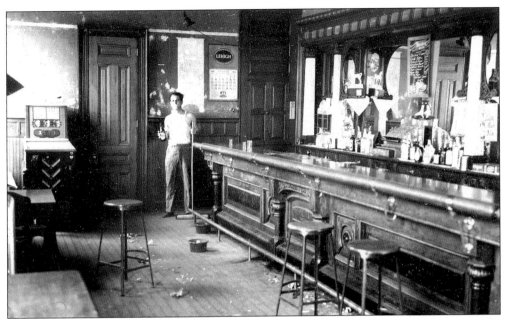

The Arlington Hotel, Second and Eugene Streets, in the 1940s. Built in 1892 by Albert Hahn, the hotel was purchased by Anthony Fritchey in 1896. The hotel once had 32 rooms. By the time the above photograph was taken on August 3, 1941, the barroom was somewhat less formal than it appears in earlier pictures. From 1892 to 1979, three generations of the Fritchey family ran the Arlington Hotel and called it home.

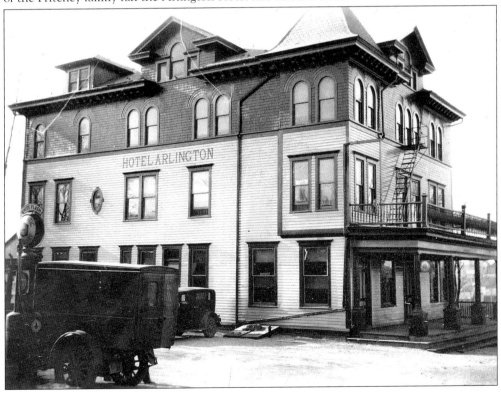

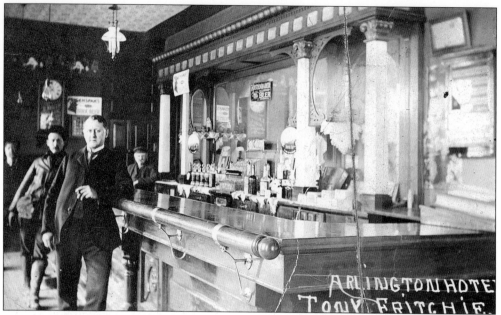

ANTHONY FRITCHEY AT HIS 20-FOOT, CHERRY WOOD-TOPPED BAR (ABOVE) AND A VIEW OF THE BARROOM (BELOW), C. 1900. The bar and bar back, which boasted round mirrors and marble pillars, remained the same through the hotel's life. They were sold at auction in 1979.

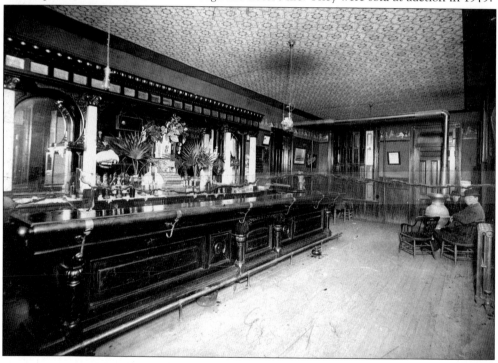

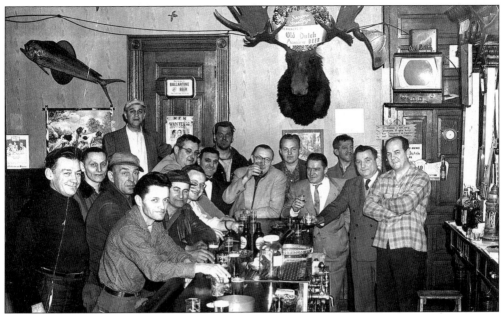

THE CATASAUQUA HOTELMEN'S ASSOCIATION, MEETING IN THE ARLINGTON HOTEL, 1955 (ABOVE). Babe Fritchey, son of Anthony Fritchey (far right), stands under the television, which drew patrons to watch ball games. One of the three moose that Anthony Fritchey bagged and mounted in the bar watches over the group. The Arlington had the feel of a country hotel, where hunters and fishermen gathered to swap stories, and sometimes store their catches in the walk-in beer cooler. The porch (below) was also a neighborhood gathering place.

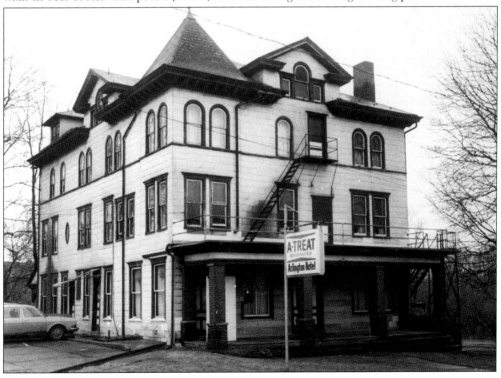

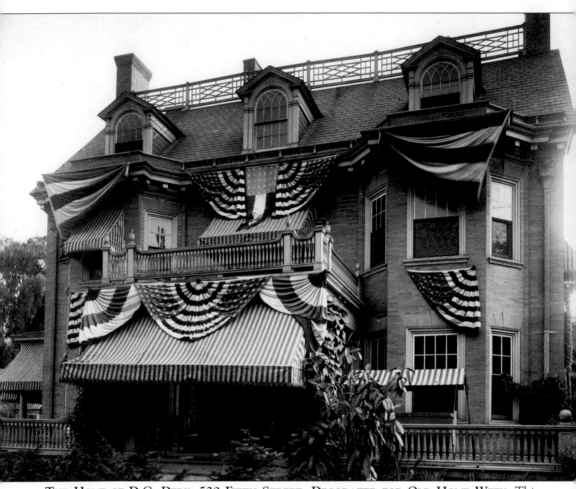

THE HOME OF D.G. DERY, 520 FIFTH STREET, DECORATED FOR OLD HOME WEEK. This house was built in 1901 and was greatly enlarged in 1917 to contain Dery's art collection.

Seven
Houses Splendid
and Simple

The most visible relics of Catasauqua's past are the houses. Though the mansions get most of the attention, Catasauqua and North Catasauqua have a remarkable number of old houses of all sorts. Entire blocks in both boroughs contain exactly the same houses they did 100 or more years ago, even though those houses have been updated inside and out—some many times. Whether splendid or simple, these houses have been cherished and cared for over the years; they are symbols of the pride and affection the residents have for their homes and their hometown.

DAVID THOMAS'S SECOND HOUSE, THE CORNER OF SECOND AND PINE STREETS. Built in 1856, Thomas moved his family here from their first Catasauqua home, now demolished, which stood at the corner of Front and Church Streets. This print from the 1876 *Atlas of Lehigh County* also shows three houses, 521, 527, and 543, that still stand on Third Street. A Pennsylvania historic marker commemorating David Thomas, one of four in Catasauqua, stands alongside the estate on Pine Street.

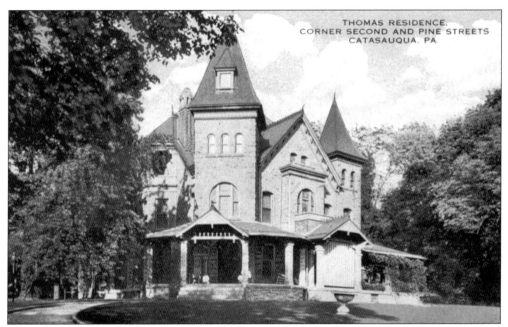

THE THOMAS HOUSE, AFTER 1905. David Thomas's grandson Edwin Thomas enclosed the walls of the original house within the black stone walls of this house, now an apartment building, *c*. 1903. Edwin Thomas, born in 1853 in Catasauqua, spent most of his professional career with the Thomas Iron Company. He spent 13 years in Thomas, Alabama, first as assistant to the president, and then as the president of the Pioneer Mining and Manufacturing Company. He returned to Catasauqua in 1899, and he became president of the First National Bank in 1903.

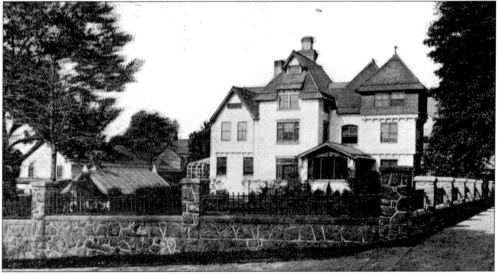

THE WILLIAMS-HOLTON HOUSE, THE CORNER OF SECOND AND PINE STREETS. Originally, this was the home of Oliver Williams, who was brought to Catasauqua in 1868 by his friend David Thomas to run the Catasauqua Manufacturing Company. Williams was also president of the Bryden Horse Shoe Company. Upon his death in 1904, his son-in-law George Holton, who married Jessica Williams, succeeded Williams both at the Bryden, and as owner of this house.

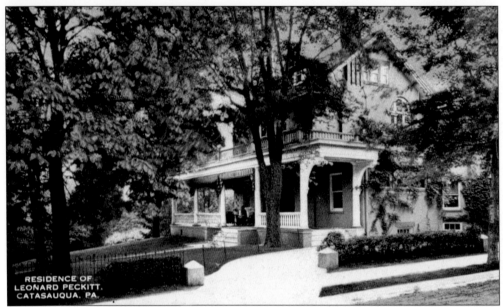

RESIDENCE OF
LEONARD PECKITT.
CATASAUQUA, PA.

THE HOMES OF LEONARD PECKITT AND D.G. DERY. Peckitt and his wife lived at 234 Walnut Street (above) from 1901 until 1916, when they moved to Allentown after the death of their only son. Born in England in 1860, Peckitt came to Catasauqua as a chemist for the Crane Iron Works in 1888. Between 1890 and 1898, he was successively assistant superintendent, superintendent, general manager, vice-president, and president of the Crane Iron Company. In 1899, he became president of the Empire Steel and Iron Company, a post he held until the company was purchased by Warren Pipe and Foundry in 1922. Peckitt spent the 30 years until his death in 1952 as an active director of the First National Bank and senior warden of St. Stephen's Church. Catasauqua's other major industrial magnate, George Dery, enlarged his house (below) to its present size in 1917, but lost it to bankruptcy only six years later.

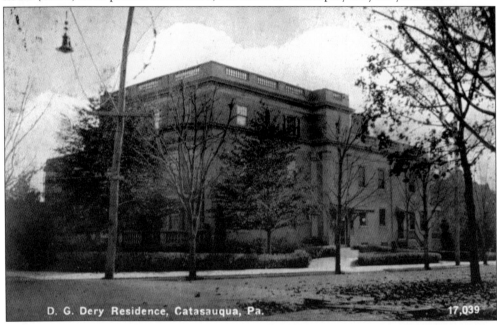

D. G. Dery Residence, Catasauqua, Pa. 17,039

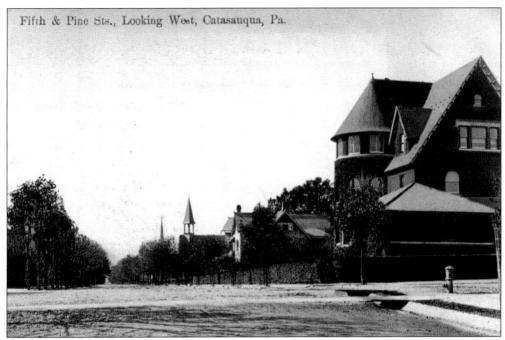

Fifth & Pine Sts., Looking West, Catasauqua, Pa.

THE SEAMAN HOUSE, 606 FIFTH STREET, AND THE DAVIES-THOMAS HOUSE, 502 PINE STREET. Directly across Pine Street from the Dery house stands this house (above), built in 1898 by Henry J. Seaman, general superintendent of the Atlas Cement Company. Diagonally across from the Dery house is a house dating from 1905 (below), which was owned at various times by members of the Davies and Thomas families connected with the foundry.

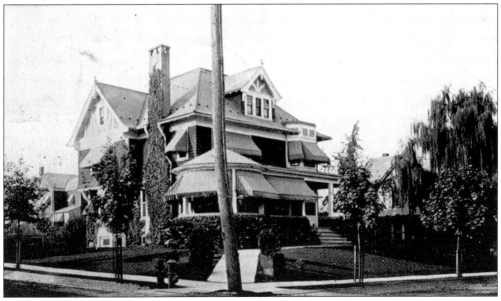

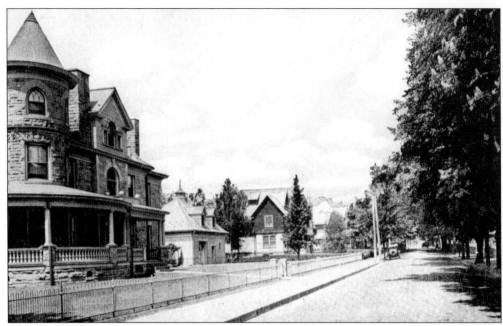

FOURTH STREET, JUST NORTH OF BRIDGE STREET. Owen Fatzinger, who was president of the National Bank of Catasauqua and a partner in the Wint Lumber Company, built this house (above) at 330 Bridge Street in 1901. Owing to his connection with the lumberyard, the house boasts extensive, exotic woodwork. Next door, at 522 Fourth Street, David Emmanel built a Tudor Revival–style home (below), similar to that of his wife's parents, the Williamses, in 1895.

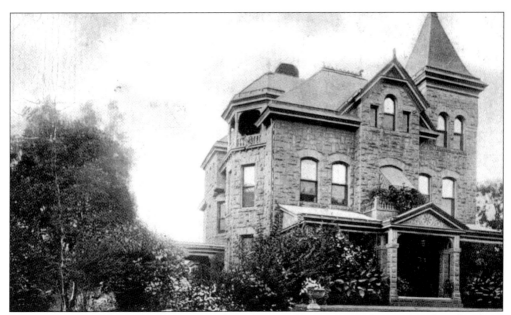

TWO FULLER FAMILY HOUSES, BRIDGE STREET AND HOWERTOWN ROAD. Neither the home of James W. Fuller Jr. and his wife, Kate, seen above, nor the home of their son, Col. James W. Fuller III, seen below, still stands. The date of the construction of the parents' house, which stood on the north side of Bridge Street, is unknown, but it appears on the 1876 map of Catasauqua. Though demolished in the 1940s, the entrances to the driveway are still in the curbs on Bridge Street. James W. Fuller III, known as Colonel Fuller, an honorary title, built a house across the street in 1904. A school had stood on this site, the southwest corner of Bridge and Howertown, since 1849, first as a Presbyterian school run by the churches and then, from 1866 to 1903, as the public Bridge Street Grammar School. The house stood until the early 1960s, when it was torn down to make way for St. Paul's parking lot and parsonage.

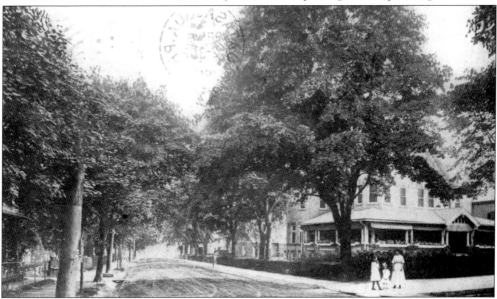

THE STINE HOUSE, 231 BRIDGE STREET, OLD HOME WEEK, 1914. Oscar Stine built this house (left), in 1900, about the time he entered into partnership in the wholesale liquor business with A.C. Kramlich. Beyond is the home of Orange Fuller, son of James W. Fuller Sr., at 235 Bridge Street. Joshua Hunt, superintendent of the Crane Iron Works from 1867 to 1882, and son-in-law of David Thomas, lived in this house (below) at Second and Bridge Streets until his death in 1886. Hunt married Gwenllian Thomas in 1844, and they had 11 children. This picture is dated July 11, 1899; the house was demolished a few years later to make way for the First National Bank building, which still stands on the site.

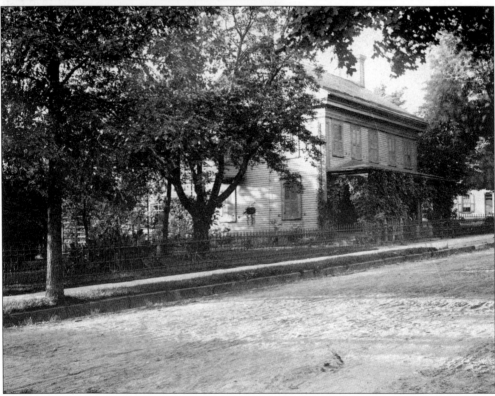

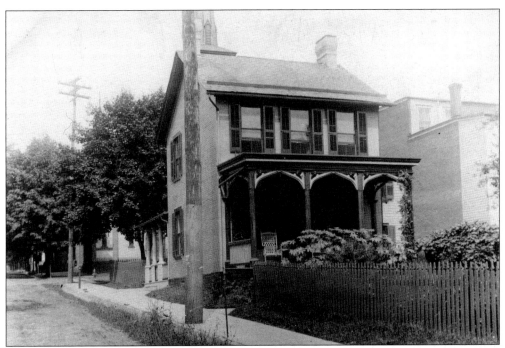

THIRD AND WALNUT STREETS (ABOVE), AND HOWERTOWN ROAD AND CHURCH STREET (BELOW). Although the construction dates of these two houses are unknown, a building that roughly fits the shape of the above one, owned by Hopkin Thomas, appears on the 1876 map. Later, this house apparently was the parsonage for St. John's Evangelical Church, next door. Kovach's store, famous for penny candy and nickel cigarettes, once occupied the house at Howertown and Church Streets (below).

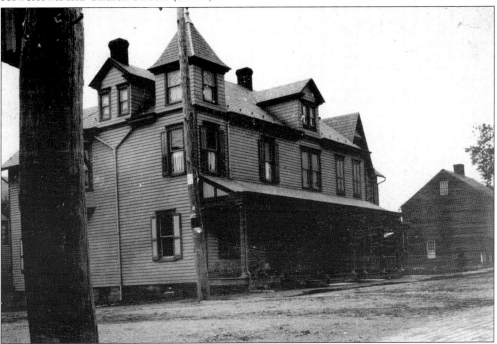

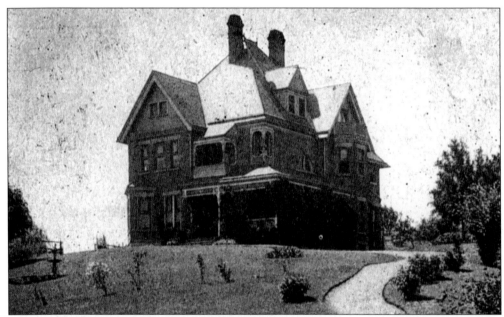

THE LEHIGH CREST SANITARIUM, C. 1905. This building still stands on the hill south of the western end of the Race Street bridge. Apparently, this was a convalescent hospital for people with tuberculosis, though the air would hardly have been pure and healthful at that location. The message on this postcard reads, "You ought to see the trains fly by this place."

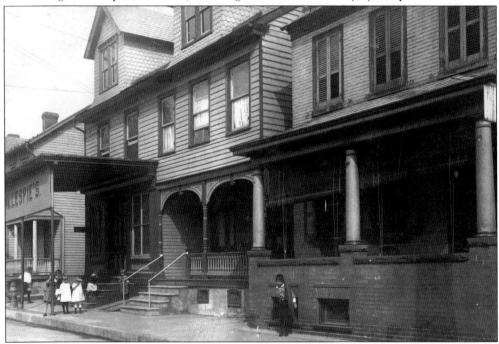

GILLESPIE'S STORE AND HOUSE, 141–143 SECOND STREET, AT MULBERRY STREET. Small stores like this were found in every neighborhood in Catasauqua. In 1953, the centennial book listed 15 small markets, several of which survived into the 1970s. Usually, the store owner lived on the premises.

SUNNY SIDE COTTAGE, HOME OF LAWYER WILLIAM J. CRAIG. This engraving is from the 1876 *Atlas of Lehigh County*. This house, much altered, still stands at 212 Bridge Street.

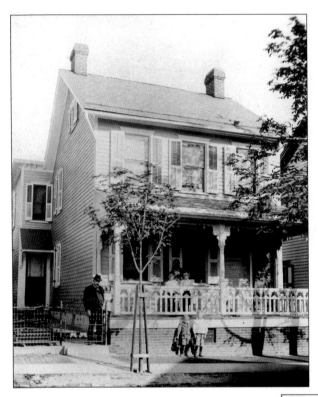

Theodore Geiger and Family, 117 Howertown Road, c. 1901. After running the Eagle Brewery Saloon for more than 40 years, Theodore Geiger opened Geiger's Seafood Restaurant up the street at 129 Howertown Road in 1944.

The Building at 110 Front Street, Decorated for Old Home Week. The first post office in Catasauqua was located in this building. Front Street had a mix of businesses, stores, and homes throughout the 19th and 20th centuries.

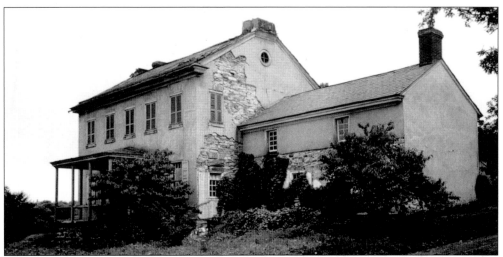

GEORGE TAYLOR HOUSE, BUILT IN 1768. Northampton County justice of the peace and Durham Furnace ironmaster George Taylor built this house on 200 acres of the Lehigh just below the Catasauqua Creek as a summer home and farm. Though not a member of the Continental Congress, Taylor signed the Declaration of Independence in August 1776. This house and Taylor's house in Easton are the only still-standing homes of signers in Pennsylvania. After Taylor's death in 1783, Col. David Deschler, who was instrumental in Pennsylvania's ratification of the Constitution, owned the house; later, it passed through the Biery and Deily families. The house was photographed by Herbert Kleppinger in the 1930s (above), when it was uninhabited. It was acquired and restored by the Lehigh County Historical Society in 1968 (below).

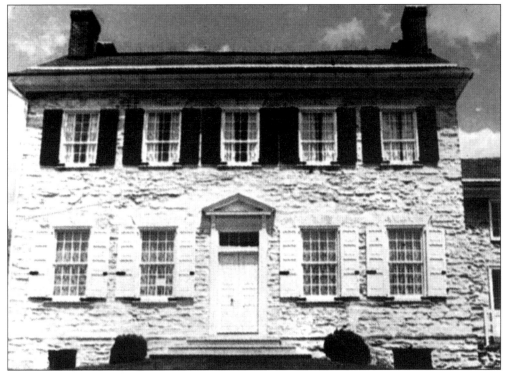

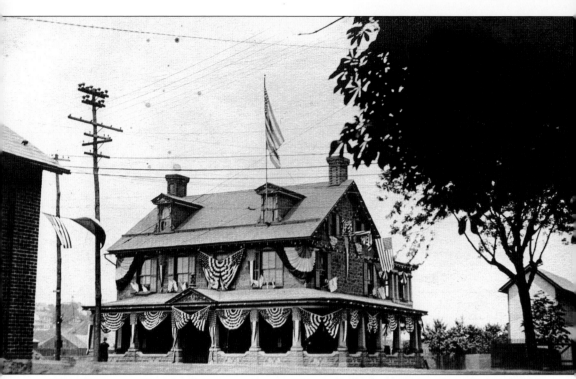

THE HOME OF GEORGE BENJAMIN FOGEL DEILY, 2 RACE STREET, OLD HOME WEEK. The original part of this house was built by Frederick Biery in 1835. A store that sold supplies to canal boatmen once occupied part of the first floor until the flood of 1862. Deily, one of the wealthiest and most colorful men in Catasauqua, operated a coal yard behind the house from 1884 until his death in 1940. Deily strung more than 500 colored lights from his house for the celebration in 1914.

Eight
CELEBRATIONS AND FAREWELLS

Catasauqua loves a parade. It does not have to be an enormously significant occasion, like Old Home Week, or the soldiers' return from World War I. Any excuse—Halloween, football victories, successful fund-raising drives, firemen's conventions—to shine up the fire trucks and take to the streets with sirens blaring is good enough. Our parades all harken back to dozens of celebrations that have swept up both boroughs through the years. Every time, Catasauqua has tried to make each event bigger and better than the one before.

Yet there are smaller, more personal, and private celebrations in these pictures, too. Some commemorate annual rituals, like holidays; others, religious ceremonies. Some simply celebrate the everyday joys of being together with families, schoolmates, colleagues, and friends. Some, perhaps, were meant to offer comfort and support for a community that was facing hard times and worries, like economic decline and sending sons off to war.

Also seen are images that signaled the beginning of the end of Catasauqua's golden age, though probably no one recognized it at the time. An expensive renovation of the iron furnace, carefully documented by remarkable photographs, could not prevent the failure of the Empire Steel and Iron Company. By 1920, the era of anthracite iron was over and so was Catasauqua's extraordinary prosperity. Nevertheless, Catasauqua has survived into another century, ready to celebrate its 150th birthday by looking back, and ahead.

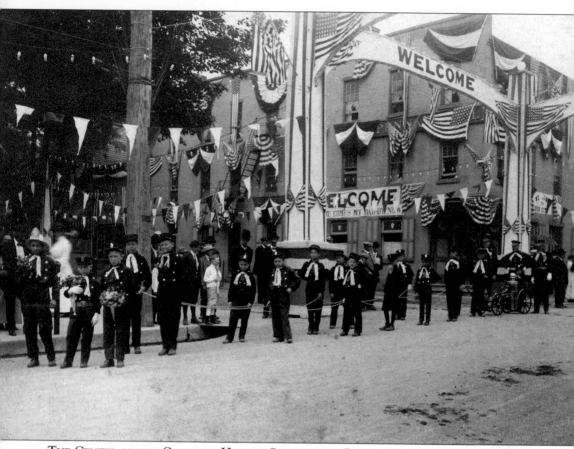

THE CENTER OF THE COURT OF HONOR, SECOND AND BRIDGE STREETS, OLD HOME WEEK, JUNE 28 TO JULY 4, 1914. On July 3, the junior firefighters pause at the center of the Court of Honor during the firemen's parade. The Court of Honor, the focal point of the Old Home Week celebrations, covered four blocks—Bridge Street from Front to Third, and Second Street from Pine to Church.

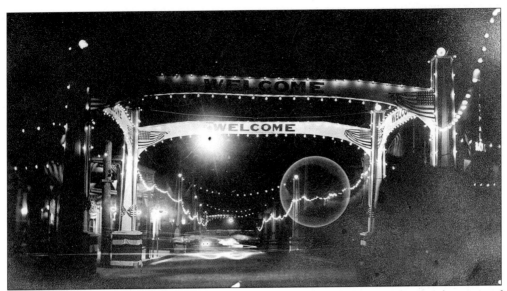

THE COURT OF HONOR. White columns strung with electric lights stood on each corner of Second and Bridge Streets (above). For one week, night was as bright as day. Columns, flags, streamers and bunting adorned every house and wire, as seen on Second Street looking north from Church Street (below).

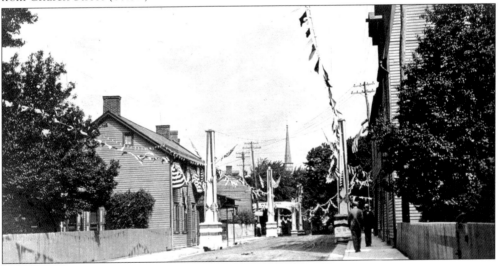

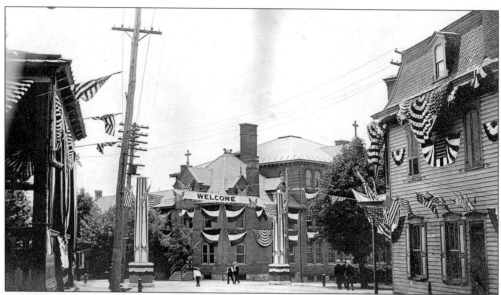

THE FIVE POINTS, WITH THE LARGEST OLD HOME WEEK ARCH. The intersection of Second, Union, and Howertown Streets boasted the largest "Welcome" arch. The Union Hotel (above, right) and St. Mary's Convent and School were draped in bunting and flags. One of Catasauqua's oldest pieces of firefighting equipment (below) was paraded proudly down Front Street on July 3.

OLD HOME WEEK PARADES, FRONT STREET. Uncle Sam (above) marches up Front Street, probably during the Fourth of July patriotic parade. Fire engines (below), both horse-drawn and motor-driven, were shown off by firemen from four counties, marching down the 200 Block of Front Street on July 3.

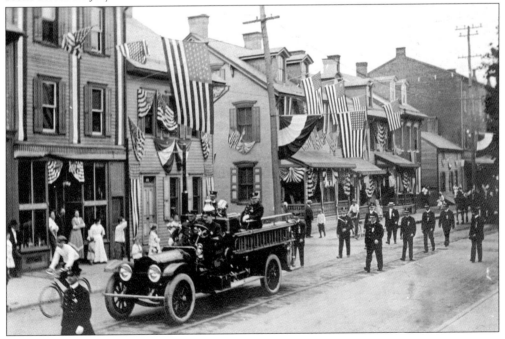

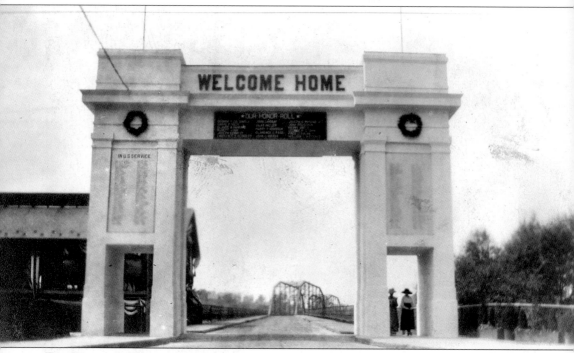

THE WELCOME HOME ARCH, PINE STREET BRIDGE, 1919. Even while Catasauqua celebrated in June 1914, war clouds gathered in Europe. One month after Old Home Week, World War I broke out in Europe. When the United States entered the war in 1917, Catasauqua sent 400 men into the service and raised nearly $4 million in Liberty bonds. On September 19, 1917, prominent citizens who owned automobiles volunteered to drive the first draftees to Allentown, and the whole town gathered at 6:30 a.m. to see them off, with church bells ringing and whistles blowing. In August 1919, the Million Dollar Town welcomed its sons back with the biggest parade in its history and this memorial arch, which was 31 feet high and 40 feet across and made of timber coated with Atlas cement. The arch remained until 1928, when it was taken down and replaced by the memorial tablet erected next to the Legion Hall.

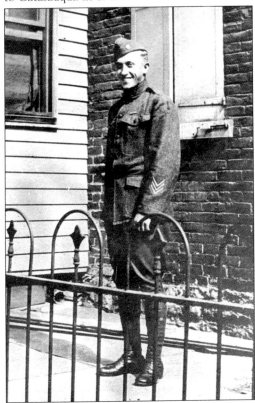

TWO DOUGHBOYS FROM THE IRON BOROUGH. This photograph of Preston Hill (right) was possibly taken before he left for Europe. The one of Leonard Geiger (below) was likely taken the day he returned to Catasauqua in 1919.

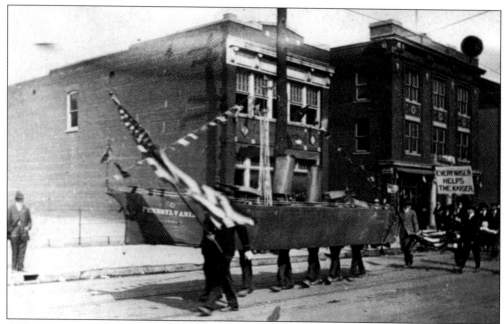

A PARADE DOWN FRONT STREET, 1918. The exact date of the parade shown in these two, and the following six, pictures is unknown but, clearly, it was a patriotic celebration and may have been in conjunction with a Liberty bond drive. A sign in the picture above reads, "Every miser helps the Kaiser," while the cannon below bears the legend "Berlin or Bust."

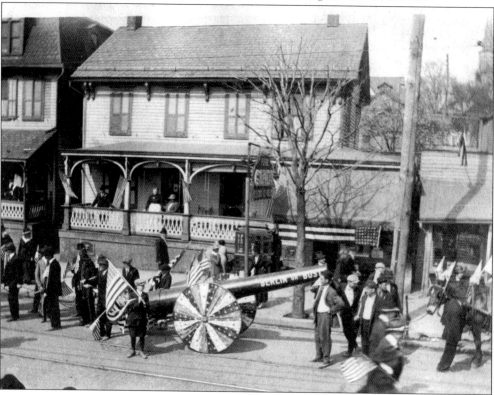

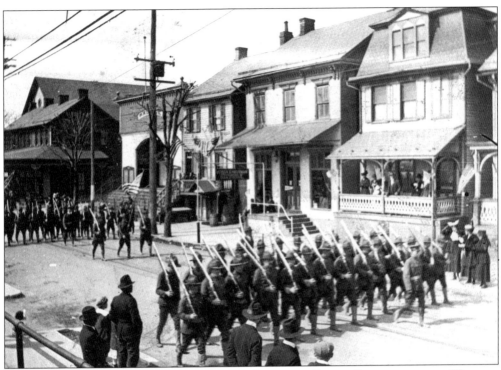

SOLDIERS AND MILITARY VEHICLES HEADING SOUTH ON FRONT STREET BETWEEN WALNUT AND PINE STREETS. The Palace Theater and the top of the Odd Fellows Lodge are visible.

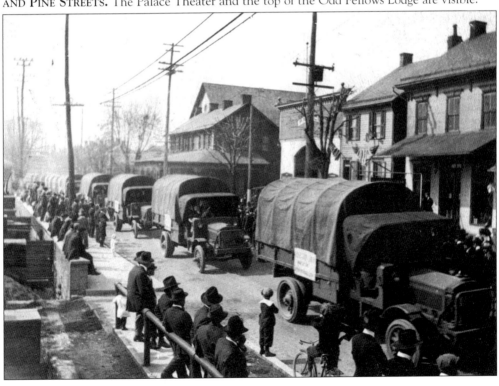

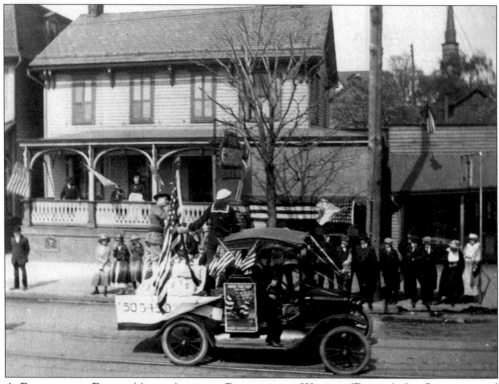

A Recruiting Float (Above) and a Pageant of Women (Below). Leafless trees and men in dark hats indicate that this parade took place sometime between November and April. The steeple of the Presbyterian church is visible in the background of the picture above.

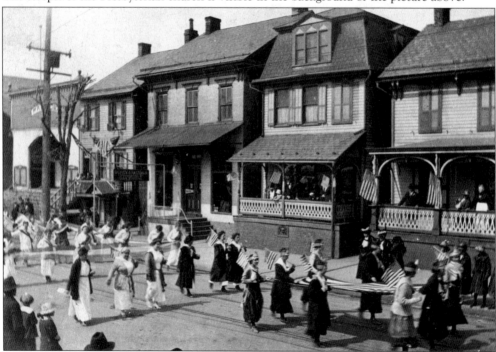

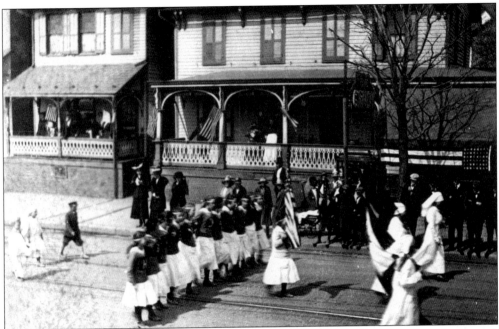

CIVILIANS MARCH DOWN FRONT STREET. Women and children, all apparently garbed in red, white, and blue, march past 617 Front Street (above). A group of men carrying flags pass by (below). In the Liberty bond and victory loan drives of 1917–1919, Catasauquans raised well over $4 million, a considerable sum for such a small, though prosperous, community.

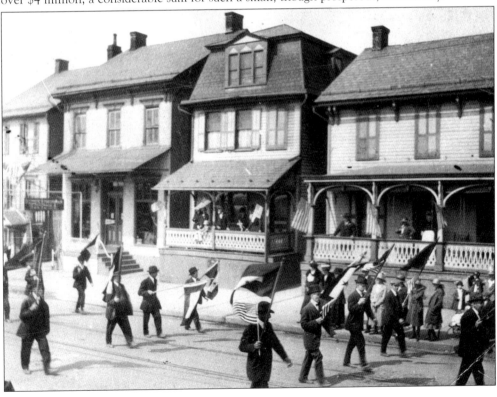

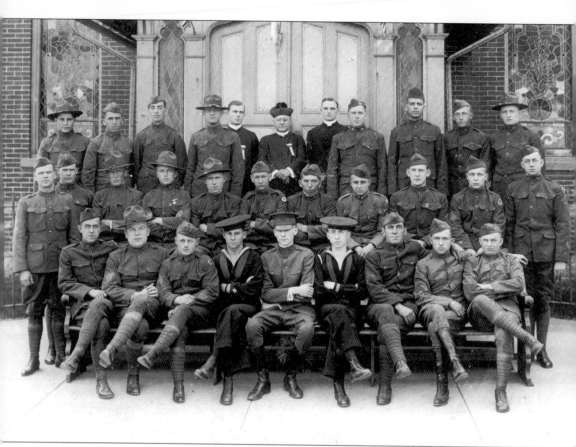

WORLD WAR I VETERANS FROM ST. MARY'S CHURCH. Soldiers and sailors from St. Mary's pose with their pastor, Rev. John Seimetz, in front of the church. This photograph was probably taken during the welcome home celebration.

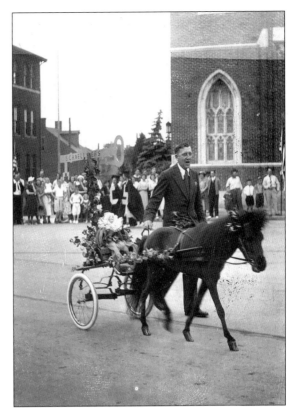

PARADE FLOATS. Catasauquans have always had a penchant for parades. Schneller Hardware displayed this charming little float (right), going though the Five Points, possibly during the Firemen's parade in 1937. The Eagle Brewery took the tanklike float out marching, but when and where this parade was held is unknown.

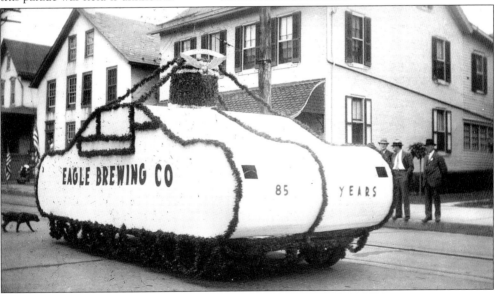

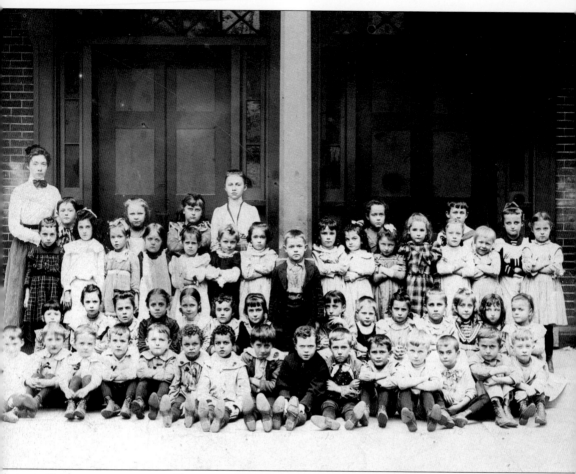

SCHOOLCHILDREN AND TEACHERS. This undated photograph was probably taken at the Front Street School.

THE 25-YEAR REUNION, CATASAUQUA HIGH SCHOOL CLASS OF 1929, JUNE 1964. Class members seen here are, from left to right, as follows: (front row) Carolyn Worseck (squatting), Naomi Koch (sitting), and Miriam Storch (kneeling); (back row) Don Douglas, Dick Gemmel, Jack Rowland, Margaret Tiffany, George Benner, Evelyn Schaden, Catherine BenVenuti, Carl Steinlicker, Harry Beitel, Will Somers, Kathryn Deily, Cap Simmers, Harold Keys, Charlotte Reilly, Hilda Fatzinger, ? Stegmeyer, Celeste Rinker, Stan G. Gayson, Millie Daniels, Jim Samuels, Clara Knies, and Elizabeth Weiss.

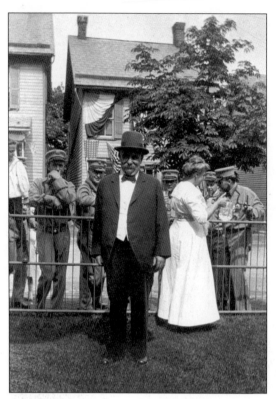

MARCHERS PAUSE FOR REFRESHMENT.
Howertown Road was often part of a parade route. Here, men who may be either soldiers or firemen are served lemonade over the fence of the house at Church Street and Howertown Road, probably during Old Home Week.

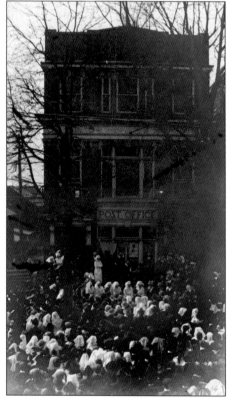

LARGE GROUP IN FRONT OF THE OLD POST OFFICE. This may be a gathering during a Liberty bond drive or, perhaps, the Welcome Home celebrations in 1919.

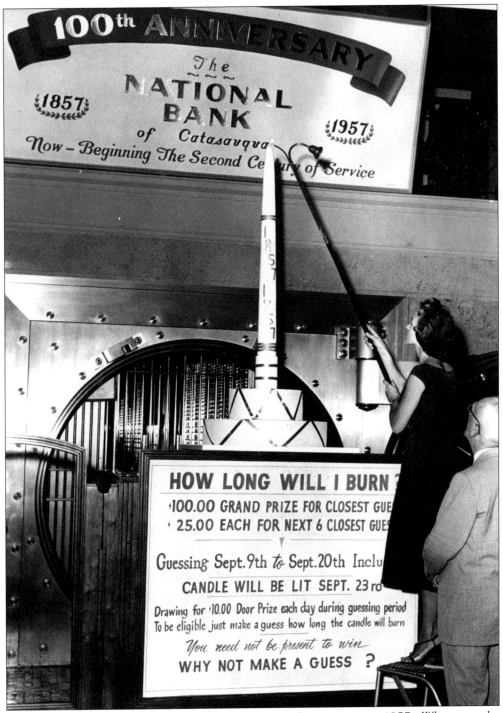

CENTENNIAL CELEBRATION, NATIONAL BANK OF CATASAUQUA, 1957. Who won the contest? Nobody knows.

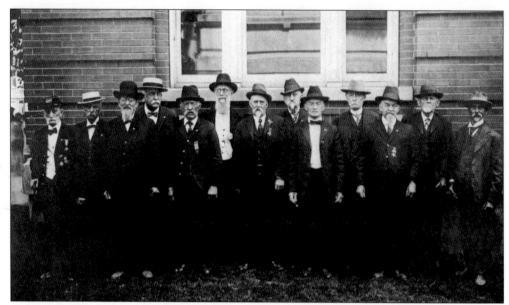

CIVIL WAR VETERANS, OLD HOME WEEK. Catasauqua's surviving Union army veterans pose alongside the offices of the Empire Steel and Iron Company. Many of these men served in the 46th and 47th Pennsylvania Volunteers and saw action in the Red River expedition in Texas. The identified men here are James Beitel, fourth from the left; Captain Matchette, sixth from the left; William Glace, tenth from the left; and William Haintz, twelfth from the left.

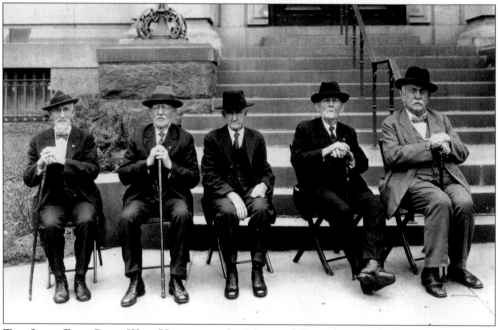

THE LAST FIVE CIVIL WAR VETERANS. On Memorial Day of 1929, the last Union soldiers from Catasauqua sat for this photograph in front of the bank. Seen here are, from left to right, two unidentified men; William Haintz, the last lock tender in Catasauqua, who died in 1934; William Glace, who died two weeks later at the age of 90; and James Beitel, Lehigh County's last Civil War veteran, who died in 1942 at the age of 99.

A Group of Friends in Front of 711 Front Street, c. 1920. An unidentified group of youths, one of whom is probably Preston Hill, enjoy each other's company alongside Buck's Restaurant.

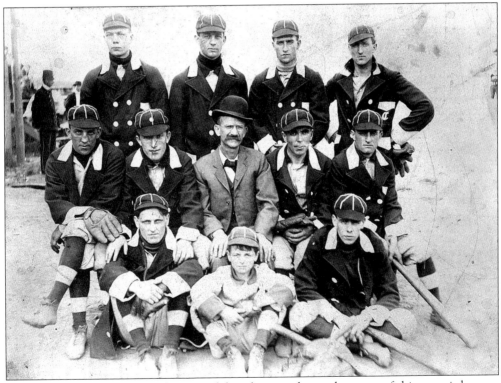

A Baseball Team. Neither the year of this photograph nor the name of this team is known, but each player sports a large "C" on his uniform. The players are, from left to right, as follows: (front row) Ritzy, Gillespie, and Long; (middle row) Eiman, Boyle, Albert, Carr, and Schlegel; (back row) Warrek, Jacko, Bohner, and Beggs.

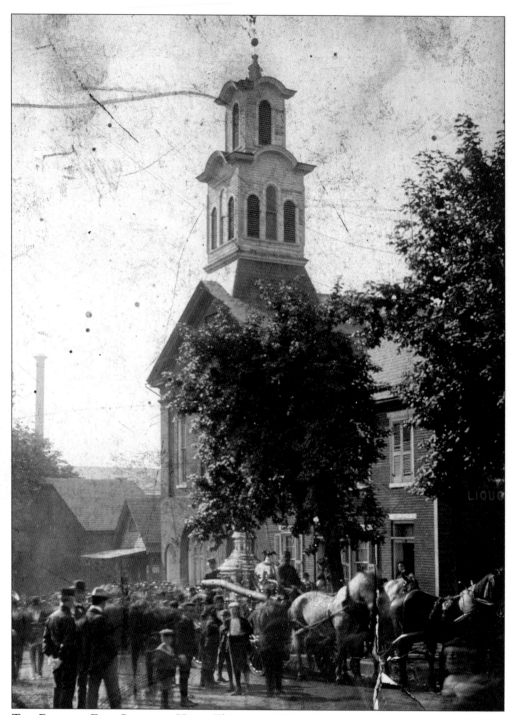

THE PHOENIX FIRE COMPANY HALL. This post–1872 gathering on Church Street in front of the Phoenix and borough hall building possibly took place before or after a parade. A sign for the Stine and Kramlich wholesale liquor business, which was housed in the building, is visible. That building still stands at 122–124 Church Street.

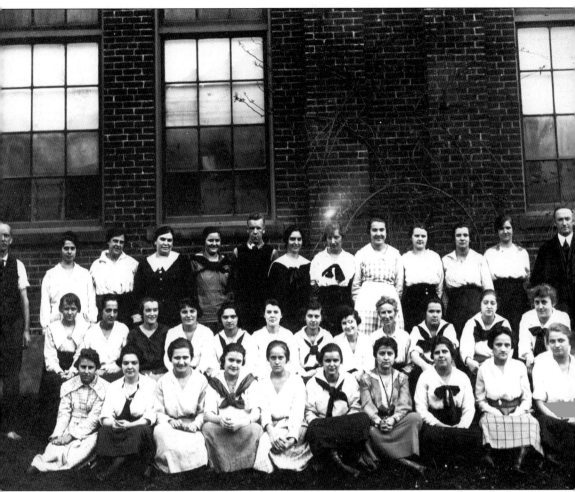

SILK WORKERS AT THE WAHNETAH SILK MILL, C. 1920S. Founded in 1890, the Wahnetah occupied the large mill on canal road that burned down in 1982. When this photograph was taken, eastern Pennsylvania was the largest silk-producing region in the world. In the 1920s, the Wahnetah had 550 employees and ran 755 looms that made broad silks and specialty fabrics, such as crepe de Chine. Catasauqua's four silk mills offered the first industrial employment for the borough's women and girls.

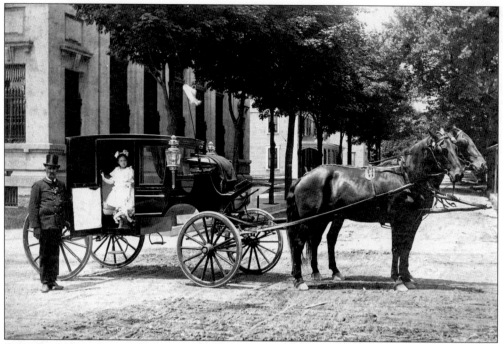

GEIGER CHILDREN OUTSIDE OF THE PENNSYLVANIA HOTEL. Proprietor John Geiger's daughter, Agnes, stands at the door of a fine horse-drawn carriage *c.* 1910 (above). Agnes and her sister Bessie, Priscilla and Anna Walker, and George Wertman ride in a more modest pony cart in front of the hotel (below).

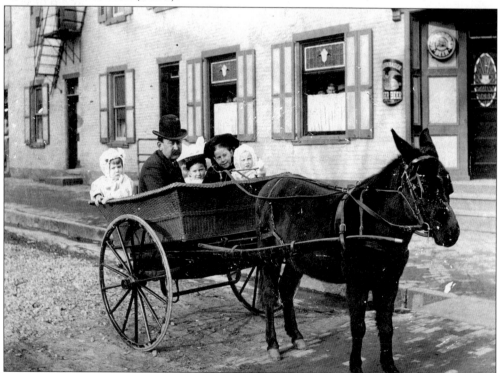

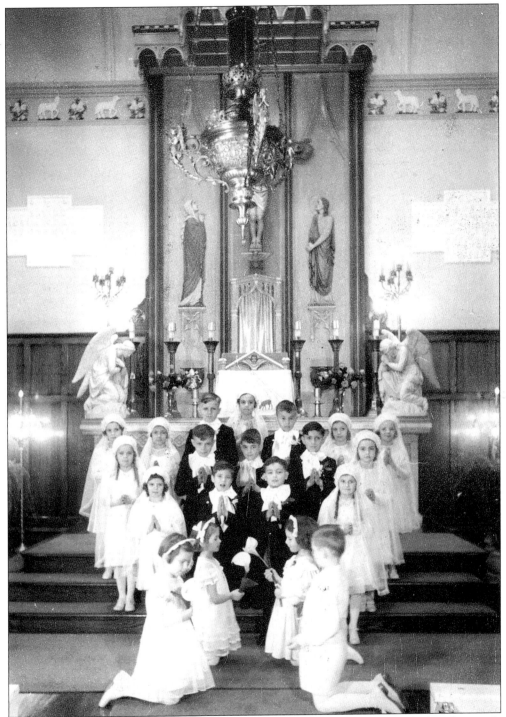

First Holy Communion, St. Mary's Church, April 12, 1942. With four first-grade angels in the foreground, second graders at St. Mary's posed in the sanctuary. The hanging sanctuary lamp and the angel light stands were removed shortly after; the interior of the church was renovated in 1981.

TRANSPORTATION MOVES ON. On December 2, 1914, a horseback rider (left) wearing Bryden Horse Shoe Company regalia seems to be trying to peer into the future near the Majestic Theater. Did he know that within 10 years, no horseshoes would be made in North Catasauqua? Just a few yards south, and 38 years later, the last trolley car to travel through Catasauqua (below) passes Edgar's store on May 10, 1953, watched by Pete Edgar and Robert McKeever.

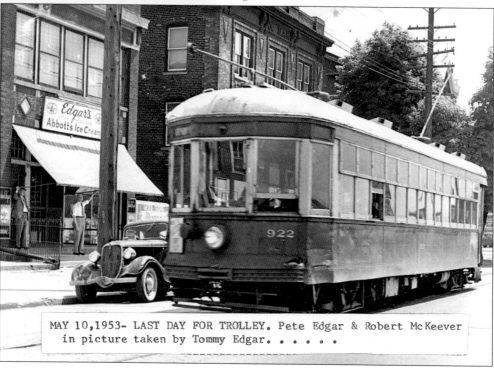

MAY 10,1953- LAST DAY FOR TROLLEY. Pete Edgar & Robert McKeever in picture taken by Tommy Edgar.

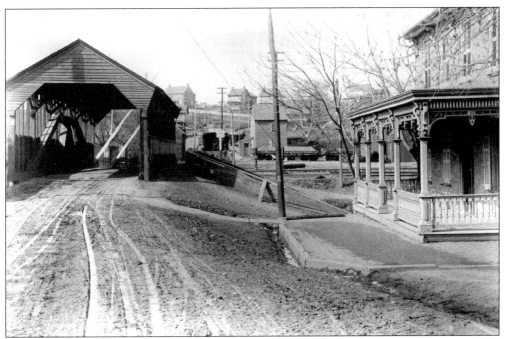

THE COVERED BRIDGE OVER THE CANAL AT RACE STREET, C. 1880. George Deily's house is on the right in this view looking west toward the canal and Lehigh River (above). The covered bridge over the river is slightly visible. The other view (below) was taken looking east toward Catasauqua. The covered bridges over the canal and river were removed in 1892 and replaced with open steel bridges that could carry electric trolleys.

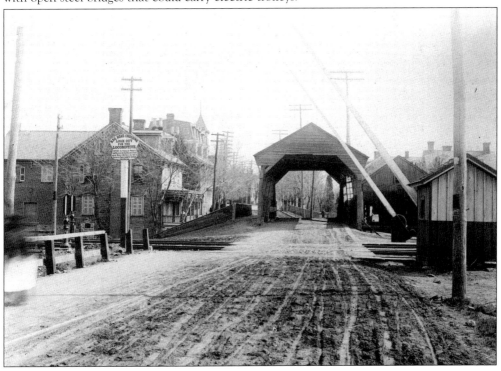

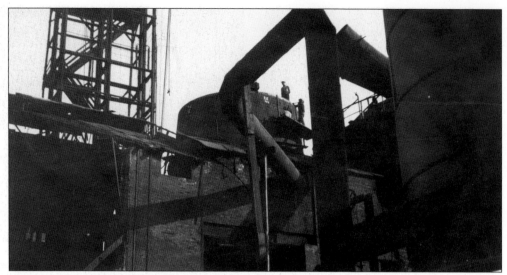

DISMANTLING THE NO. 2 FURNACE OF THE CRANE, SEPTEMBER 1919. In the fall of 1919, the Crane embarked on a renovation project that centered around replacing the old No. 2 furnace, which had been in use since 1908. This was an optimistic step considering that the future of the anthracite iron business looked bleak and the country was in the grip of a recession. The process was documented in an extraordinary series of photographs, 10 of which are included in this book. Progress was swift the first day, September 18 (above), as a heap of scrap from No. 2 attests in a photograph taken the following day (below).

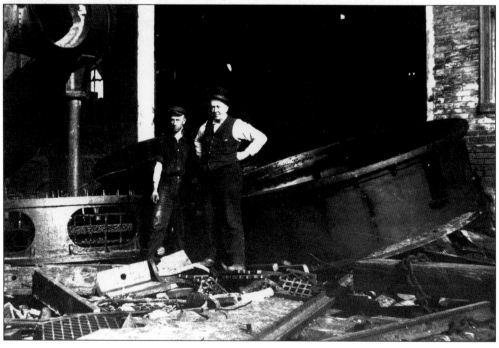

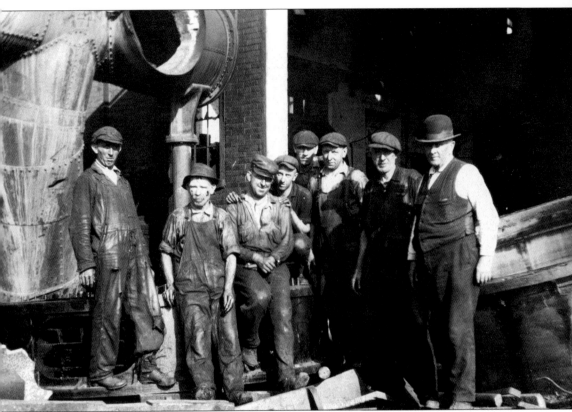

DISMANTLING THE NO. 7 BLOWING ENGINE, SEPTEMBER 19, 1918. A gang of Crane workers stands in front of pieces of the old blowing engine, which forced hot air into the furnace. These men probably hoped to resume their old jobs at the furnace, but modern equipment could not keep the company in business.

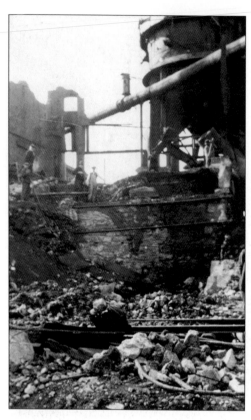

RUBBLE OF THE CAST HOUSE NO. 2
FURNACE, NOVEMBER 8 (LEFT) AND
NOVEMBER 16 (BELOW), 1919. The furnace
and cast house were ripped down to the
foundations. Stores and businesses, including
the Mansion House and Miller's store, are
visible on the far side of Front Street.

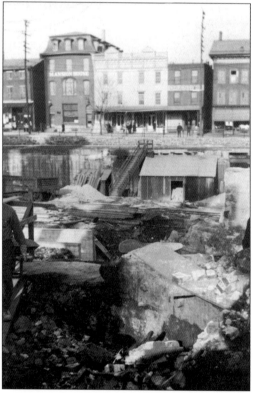

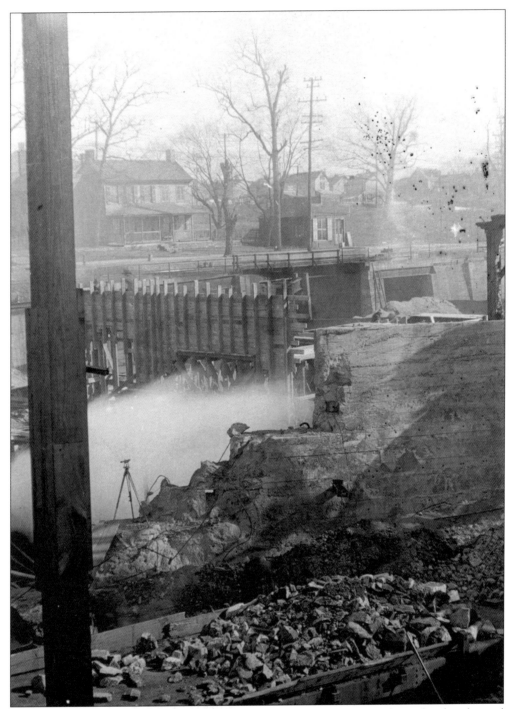

A GENERAL VIEW OF THE STOVES, DECEMBER 10, 1919. Concrete forms for the elevated trestle (still standing on the Fuller Company site) are in the center of the image, while David Thomas's house (since demolished) and the small building that still stands on Front Street south of Church Street are seen.

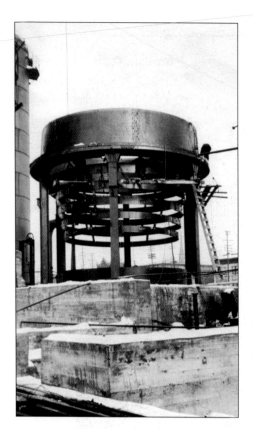

THE SHELL OF THE NEW NO. 2 FURNACE, FEBRUARY 7, 1920. By mid-winter, all of the new foundations for the furnace were built, and the furnace itself began to go up. Eventually, it would reach 60 feet.

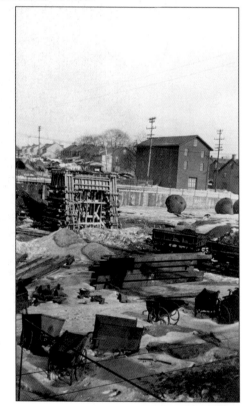

THE CONSTRUCTION OF THE TAIL TRESTLE, FEBRUARY 16, 1920. Wooden forms surround a support of the new tail trestle, which would carry rail cars of slag away from the furnace and through the tunnel to be dumped at the cinder tip in East Catasauqua.

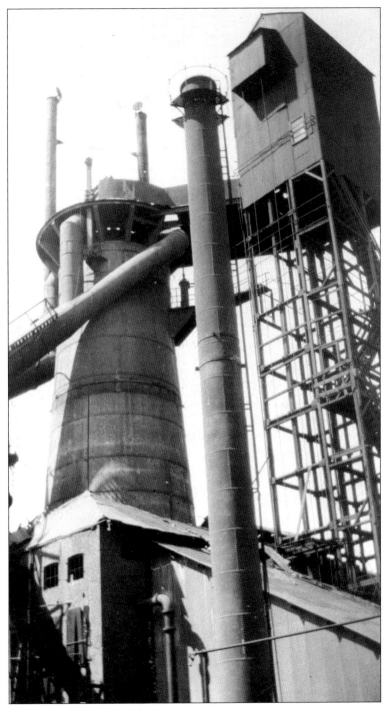

THE NEW FURNACE NO. 2 IN THE SUMMER OF 1920. The $1 million renovation was futile. A poor economic climate in the iron and steel industry paired with the lingering effects of a severe recession forced the shutdown of the new plant only nine months after it opened. The new furnace never produced any commercial amount of iron, and the entire plant was scrapped by 1930.

ACKNOWLEDGMENTS

It would not have been possible to compile this book without the cooperation, support, encouragement, advice, and good will of many people. Thanks to Ray Holland and Carol Front, archivist at the Local and Industrial History Archive; Lance Metz of the National Canal Museum; Martha Birtcher and the staff of the Public Library of Catasauqua; Bernard Ferenchak and Ben M. Ferenchak; Larry Tait; Betty Rabenold; Ray and Rita Sheetz; Betty Arey; Louise Fritchey; Martha G. Capwell; Susie Smith-Levine of the Catasauqua branch of First Union Bank; Sally Chromiak; Hilda Barna; Ann and Mike Nederostek; and Vince and Chris Smith. Thanks to Bobby Burkhardt and Judy Gemmel for their excellent history of Catasauqua, as well as to the authors of the 1914 and 1953 books, without whose work so much of our history would be irretrievable. Thanks to Joe, Paul, and Amanda for their love and patience.

FIRST-GRADE ANGELS OUTSIDE OF ST. MARY'S, FIRST HOLY COMMUNION DAY, MAY 1958. The gowns were of silk from Cands Fabrics, which occupied the former Wahnetah Mill on the canal road from 1930 to 1970. The angels shown here are, from left to right, as follows: (front row) Victoria Bugbee, Regina Fink, Janel Shenkel, and Kathleen Foley; (back row) Glenda Shuster, Mary Ann Sodl, Barbara Ferenchak, Ann Sperlbaum, Martha Capwell, and Anne Marie Saylor.